D0710108

THE
MERRITT
PARKWAY

THE
MERRITT
PARKWAY

THE ROAD
THAT SHAPED A REGION

Laurie Heiss & Jill Smyth

THE
History
PRESS

Published by The History Press
Charleston, SC 29403
www.historypress.net

Copyright © 2014 by Laurie Heiss and Jill Smyth
All rights reserved

Front cover, bottom: Painting courtesy of Cynthia Mullins.
Back cover, right inset: Courtesy of Tod Bryant; *bottom*: Painting courtesy of Cynthia Mullins.

First published 2014

Manufactured in the United States

ISBN 978.1.62619.635.3

Library of Congress CIP data applied for.

Notice: The information in this book is true and complete to the best of our knowledge. It is offered without guarantee on the part of the author or The History Press. The author and The History Press disclaim all liability in connection with the use of this book.

All rights reserved. No part of this book may be reproduced or transmitted in any form whatsoever without prior written permission from the publisher except in the case of brief quotations embodied in critical articles and reviews.

Dedicated to the thousands of people who have stood up or cheered for the Merritt Parkway for nearly a century. Thank you. It is you who shaped this region we call home.

CONTENTS

PREFACE

In writing this book about a historic roadway, we have tried to demonstrate that any part of our cultural heritage worth preserving has more than utility; it has something else. The Merritt Parkway is entwined with the history of its people and vice versa. The tension between special status and utility has created conflict regarding this parkway. Utility or charm? Transit artery or historic resource? We believe it can be both.

In this book, we hope to show the reader why the Merritt is a different road, still beloved as it approaches its seventy-fifth anniversary. The parkway is a precious collection of diversely styled bridges with a touch of whimsy; they represent monumental public architecture. In addition, an unknown but well-trained landscape architect designed a unique driving experience with trees and shrubs, one of the earliest examples of context-sensitive development, years before its time. And the roadway designers worked with the topography to design curves and views that are a delight for drivers. We owe them thanks, for it could have resembled the speedy but sleep-inducing Pennsylvania Turnpike.

Both of us have worked as executive director of the Merritt Parkway Conservancy, which has afforded us an inside view of the Department of Transportation. We appreciate its challenges in balancing utility with preservation. We have also worked with many fine people who care deeply about the fabric of the region and southwestern Connecticut—Fairfield County, in particular. They care about aesthetics, and they know there is real value in preserving pieces of our cultural heritage.

We want to engage a next generation to discover the differences between homogenized surroundings and special places. We have tried to make the story about the people and the place. We have thought about what cars people would be getting into as they drove off and merged onto the Merritt over the decades and what songs they were singing along to as they drove under a delightfully detailed bridge or alongside a flashy orange maple tree nestled among mountain laurels. So start each decade by putting yourself in that car and singing that song—go find the YouTube videos if you don't know these tunes! For more information and to understand the stories behind the featured cars and the songs, please visit us on Facebook at Merritt Parkway Authors the Road That Shaped a Region. For amazing photos and history of the parkway, please also see the Library of Congress, www.loc.gov/pictures/collection/hh/, including the entire documentation written by the National Park Service in 1992.

LAURIE HEISS & JILL SMYTH

Acknowledgements

We would like to thank the historic societies—particularly the archive/ research teams in the following towns: Fairfield, Greenwich, New Canaan, Stamford and Stratford. We also appreciate the help of the History Rooms in the Bridgeport and Norwalk libraries, the Connecticut State Library and the Connecticut Trust for Historic Preservation, where we appreciate the leadership of Helen Higgins and Chris Wigren, exemplary editor. We thank our friends at the Connecticut Department of Transportation who contributed material to this book and to all those DOT employees who have cared for the Merritt with enthusiasm over many decades.

We are grateful to individuals who loaned or contributed material to us and who provided interviews: Maryanne Guitar; Victor DeMasi; Jim Vose; Henry (Buzz) Merritt; Jim Snedeker; Herb Newman; the DeLuca family; the Wise family; and photographers Tod Bryant, Nate Gibbons and Eric Seplowitz. We thank Cynthia Mullins for her enduring interest in capturing the Merritt Parkway in her many lovely paintings and appreciate her consent to use two of those images on our cover. We also appreciate materials lent or received from Mrs. Larry Larned, Marguerite Shuck, Mary Baier and Catherine Lynn. A special thank-you goes to the founders— including Emil Frankel and particularly Dee Winokur and Peter Malkin— for their leadership and support of the Merritt Parkway Conservancy, and thanks to our dedicated board members. A special thanks to Robert and Catherine Sbriglio for their lobby space in a museum dedicated to "all things Merritt Parkway," for photographs and for their support of many parkway

celebrations in the town of Stratford. Thank you to Erskine and Middeleer Associates for years of landscape oversight on the parkway.

We appreciate all the folks at The History Press who worked behind the e-mails, and we thank Tabitha Dulla and Julia Turner for their patience.

On a personal note, I'm grateful to my son Connor Grealy, a history concentrator, and to Neil Grealy—both great readers and editors. Thanks for accepting the takeover of the house by book materials.

LAURIE

As always, I appreciate the help of my two sons, Brad and Matt, for being my research assistants and buyers of Merritt ephemera. Also, thank you to my mother for listening.

JILL

1

THE 1920S AND OVERVIEW

The Case for an Alternative to the Post Road

Car of the Decade: Ford Model T
On the Car Radio (well yes, there wasn't one yet, but soon): "Bulldog," (the Yale fight song) by Cole Porter

Ah, the Roaring Twenties. By the end of this decade, 20 percent of Americans owned a car. In 1928, you could purchase a Ford Model T for $295. In addition to the automobile industry itself—led by Ford, GM and Chrysler—the supplier industries providing steel, plate glass, rubber, leather and gasoline were booming as well. In turn, as these ten million cars came off the assembly line, they created the need for restaurants, hotels and garages and a way to get to all of these places—roads. What follows is the story of a beautiful and beloved road, a queen among the parkways: the unique Merritt Parkway. Starting at the New York state line, it traverses thirty-seven and a half miles of southwestern Connecticut, ending at the Housatonic River. What makes this road deserving of (another) book in its name? At least one of the reasons is because "it was one of the last great parkways constructed according to the early 20th century parkway principles. The era of the fully integrated transportation facility and landscape as a state highway ended with the Merritt Parkway."[1]

It is the only roadway—anywhere—that has evolved with nearly continuous public participation in the form of citizen action groups and organized support, which began before it was built and has continued throughout most of its seventy-five-year existence.

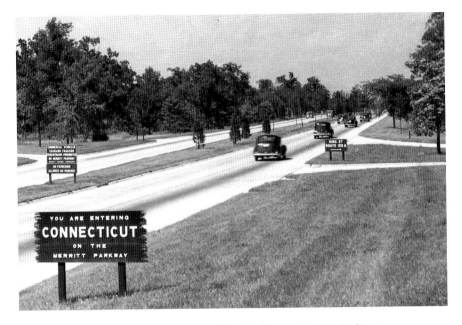

The Merritt Parkway is perhaps the most distinctive feature of Fairfield County, Connecticut. *Courtesy of Collection of Connecticut Department of Transportation, Library of Congress, HAER CONN,1-GREWI,2—82.*

The Merritt is at the heart of the idea that safety and historic preservation need not be mutually exclusive. "Any community gets what it admires, will pay for, and, ultimately, deserves…And we will probably be judged not by the monuments we build but by those we have destroyed."[2]

Perhaps most importantly for the millions of people in the tri-state region who have traveled the Merritt Parkway, it is a beautifully landscaped road decorated with seventy-two original bridges that are recognized as works of art and monumental public architecture. It is a road that has shaped this region: New York City, Westchester County and most of Connecticut.

IN THE BEGINNING

The Post Road, a "Cultural" Road Evolved from the First Trails

More than 100,000 cars and trucks were registered in the small state of Connecticut by 1920, and New York City had almost 140,000 cars registered.

They had to drive somewhere, and mostly on weekends, many New Yorkers would find themselves crawling along the Boston Post Road through tony Fairfield County, just north of the city, along with local residents' autos and unsightly, loud through trucks. Prior to suburbanization, Connecticut was the land of bucolic and historic farms. Back roads featured majestic oaks, elms and chestnut trees with stands of pines in the distance. Charming beaches lined the north shore of Long Island Sound, and rivers running north–south coursed through the surrounding hills. Connecticut was the place for a perfect weekend getaway or a drive to the Yale Bowl for a football game, raccoon coats and picnic baskets in tow. As a 1913 *Greenwich Press* headline reads, "Putnam Avenue Now a Great Highway; Going to the Football Game at New Haven Saturday Thousands of Automobiles Passed Through Greenwich." Yes, as a form of entertainment, residents along the Post Road (aka Putnam Avenue in Greenwich, named for General Israel Putnam's famous escape from the British on horse) pulled up chairs and watched new and different cars crawl by with Bowl-bound fans singing Yale fight songs and wearing city fashions. The up-and-coming Fairfield County "through-route" and local residents suffered from congestion in proportion to the growth of car ownership and affluence in the New York region. Also known as U.S. Route 1 (after 1925, when the U.S. Highway System was created by the Federal Highway Act to reduce confusion on multiname highways that were haphazardly signed with color codes), it was the only direct route through Connecticut and served as part of the direct route between New York and Boston. Route 1 featured a confusion of traffic, intersecting roads, speed traps, wayside businesses, scores of traffic signals, unclear signage, stopped delivery trucks, short tempers, overheated radiators resulting in frazzled nerves, pedestrian-car accidents, car-car accidents, car-truck accidents and car–stationary object accidents.[3]

In 1922, some of New York's most prominent business and professional leaders joined forces to launch an ambitious effort to survey, analyze and plan the future growth of the metropolitan region. Known as the Regional Plan Association (RPA), this initiative was the first to recognize a New York metropolitan region encompassing Connecticut and New Jersey. Planning as a concept had evolved in this growing metropolitan area, and the Committee of the Regional Plan of New York and Environs, largely funded by the Russell Sage Foundation, had begun to address traffic, transportation and road planning as a part of many planning topics, including a new road through Connecticut. By 1923, Connecticut highway commissioner Charles Bennett had commenced studies of the Post Road through Fairfield

County that indicated some relief was imperative. Subsequent highway commissioner John Macdonald, via a state representative, introduced a bill in the 1925 legislature to fund a traffic survey of the Boston Post Road in Fairfield County. This included traffic counts and potential alternative paths for a new roadway. Papers featured pictures of traffic counters sitting alongside the Post Road, but the problems were evident: accidents were increasing, travel was impeded, trucks exacerbated crowded conditions and billboards lined the way. Distracted drivers and honky-tonk establishments created diversions and parking issues. Meetings were held in towns along the crowded Post Road and widening was discussed during the late '20s. But usually after that discussion, an alternative road was discussed and favored. In the end, both remedies were needed to keep traffic moving through Fairfield County and across the state and between Boston and New York City.

SOME QUESTIONS FOR THOSE ROAD PLANNERS OF THE 1920S AND THE FAIRFIELD COUNTY PLANNING ASSOCIATION

Who will pay? Who plans the path of a road? Which state agency is in charge of building roads? Where does it go and why? To what does it connect?

The Connecticut legislature wrestled with who should be in charge of the planning and where the money should come from—should the whole state pay for a "regional" road? Meanwhile, starting in June 1924, the power behind the vision for the Merritt Parkway rested with the Fairfield County Planning Association (FCPA). FCPA, headquartered in the Bridgeport Chamber of Commerce, was chartered with the building of a road in Fairfield County as one of its chief objectives under the larger banner of introducing planning as a concept to preserve the particular look and feel of Fairfield County. This organization, with its road-building focus, was influenced by the Regional

Opposite, top: The "Roaring Road"—the Boston Post Road, aka U.S. Route 1—was the only direct route through Connecticut's densely populated urban corridor until 1940. *Courtesy of Larry Larned Collection.*

Opposite, bottom: This 1928 map from the Regional Plan Association shows the maximum amount of utilization of the existing system of highways. *Courtesy of the Regional Plan Association.*

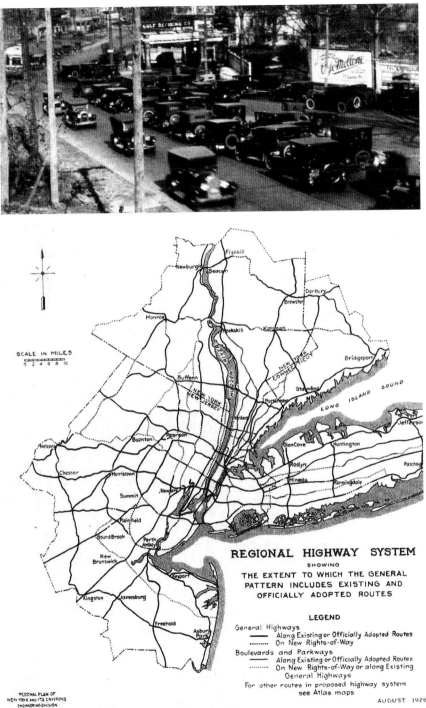

REGIONAL HIGHWAY SYSTEM

SHOWING

THE EXTENT TO WHICH THE GENERAL
PATTERN INCLUDES EXISTING AND
OFFICIALLY ADOPTED ROUTES

LEGEND

General Highways
—— Along Existing or Officially Adopted Routes
········ On New Rights-of-Way
Boulevards and Parkways
—— Along Existing or Officially Adopted Routes
········ On New Rights-of-Way or along Existing
General Highways
For other routes in proposed highway system
see Atlas maps

AUGUST 1928

REGIONAL PLAN OF
NEW YORK AND ITS ENVIRONS
ENGINEERING DIVISION

Plan Association's pamphlet in 1925, "Some Preliminary Suggestions for the Relief of Highway Congestion for New York and its Environs." The members, appointed by the governor (two from each of the twenty-three towns in the county and numerous additional subcommittee members), were established community leaders, local professionals or politicians. There were FCPA members, such as longtime chairman Daniel Sanford of Redding, who were also active members of the Regional Plan Association.

There was no model for regional planning across state lines and across shared roadways before these two somewhat related groups came into existence. The 1934 report of the Fairfield County Planning Association was called "First Planned County in New England" and introduced the concept of planning and zoning principles when only one or two towns in Connecticut (Danbury was the first) had incorporated planning processes and regulations into their local governments. Unlike other states, the county structure in Connecticut had few responsibilities and narrowly defined authority until 1960, when the county structure and employee positions were abolished altogether by the General Assembly, leaving Fairfield County to be merely a geographic footprint without taxes, representation or structure. In addition to the many dedicated participants of the FCPA working toward a new parkway, the legislature also created, in 1931, the Merritt Parkway Commission with gubernatorial-appointed members. Several of the commission members also had a role in the FCPA.

Connecticut highway commissioner John Macdonald, a Democrat appointed by Democratic governor Wilbur Cross and retained by Republican replacement governor Raymond Baldwin, arguably felt he was in charge of the roadway, its path (as he was directed in 1927 by the legislature to survey) and its construction. However, he also realized the value of constant PR in the form of town meetings across the county to exchange views on this life-changing road and the Post Road congestion remedies. Macdonald had to deal with the FCPA heavyweights, the empowered Merritt Parkway Commission, local first selectmen and mayors, legislators, old-fashioned power brokers, the construction industry, the old-time Connecticut Yankees and the new elite. He also had to deal with RPA representatives as they strategized for roads in Connecticut to help them in New York—and so the confluence of influences emerged in the tri-state area. Oddly enough, in a snobbish rebuff of invading interlopers from less glamorous parts of New York, the Fairfield County conservatives were initially against connecting the upcoming Connecticut parkway with the existing Hutchinson River Parkway, whose original eleven-mile section was completed in 1928.

The one concept all these factions would ultimately agree to was that Connecticut would build the most beautiful and safest parkway in the nation. *Parkway* was the loaded word for all it implied. This was saying the road would be even better than the original, Robert Moses–directed parkways of neighboring New York: the Bronx River Parkway (completed in 1925), the Henry Hudson Parkway (completed in 1937) and the Hutchinson River Parkway (1924–38). These were the benchmark and flagship parkways of the nation, along with the "parkway-freeway" under construction in California, the Arroyo Seco Parkway (also known as the Pasadena Freeway), at the same time. The Merritt Parkway would be designed "in-house," not using the consultants who had been hired to design most of these other parkways. It was the era of the City Beautiful movement, and in the context of designing a parkway, public monumental bridges and planned landscapes were the current design trends. This movement influenced the architect's designs for the seventy-two different bridges, incorporating Beaux Arts and Classical styling, among many others.

What's in a Name?

A popular Republican congressman for eighteen years (1917–31 and 1933–37), Stamford resident Schuyler Merritt was the clear choice to lend his name to the new road, and the house-dominant Republicans rallied around him. By 1930, it was the descriptor, not the name of the road, that was constantly argued: highway, boulevard or parkway? Highway commissioner Macdonald said, "The time before the Merritt Boulevard is a fact would be shortened if Fairfield County people would stop calling it a boulevard."[4] The term *boulevard* annoyed him because people in other parts of the state then wanted one of those boulevards for their community. Leaders, legislators and voters in other parts of Connecticut did not experience firsthand the deplorable traffic conditions and high accident rates on the Post Road in Fairfield County. Therefore, some legislators were opposed to spending state dollars in that small southwest corner of the state.

Commissioner Macdonald preferred the term *parkway*, and so what started out as the Merritt Highway was aggrandized for a brief period by being called a boulevard and ultimately ended up being a parkway. The name *parkway* was also what the FCPA and the Merritt Parkway Commission wanted, as long as it meant no trucks, grade separation (aka limited access),

Old Ridgewold Inn

A PLANNED
COUNTY
EMERGES

Fairfield County Planning Association introduced planning concepts to maintain the
county's beauty and favored a "parkway" free of trucks and roadside blight in this journal.
Courtesy of Bridgeport Public Library History Center, Bridgeport, Connecticut.

park-inspired landscaping, controlled shoulders void of billboards and
median-divided traffic. A parkway was even described by the FCPA in its
February 1934 booklet—"It will pass through relatively open country where
sufficient width may be obtained to build an adequate modern parkway...A
parkway is a public road through public or park property"—in case anyone
was not getting the message.

Perhaps the reason citizens were so emphatic about the parkway concept was that the previous commissioner Charles Bennett (1913–23) had proposed an alternative road that might offload truck traffic onto the new parkway, and the citizenry was opposed to commercial traffic being allowed on its proposed new road; therefore, the terms *highway*, *boulevard* and *parkway* were much more charged than would seem called for. In fact, the FCPA exerted design influence by educating the public about what the term *parkway* implied and why that was important. Eventually, after years of fits and starts, on the last day of the General Assembly in 1935, the legislators passed a bonding bill that also formally introduced a name change from the original "Highway." With the signature of Governor Cross on June 13, 1935, the Merritt Parkway was officially born as a project with a funding mechanism and a new name loaded with implicit and grandiose expectations. So began the legacy of road building in Connecticut.

At the time of the delayed 1935 signature formalizing the "Merritt Parkway," there were already land parcels purchased, contracts in process, hills graded and cuts (ravines) filled with full-scale media coverage detailing the road's every move, speculating about the route and celebrating every advancement. In fact, one of the first segments of the parkway was built at the eastern terminus in Stratford, where the road was initially planned to reunite with the old Boston Post Road prior to heading over the Housatonic on the Washington Bridge into the Devon area of Milford. Citizens and the FCPA lobbied for a more northern route over the Housatonic. This route would require a new bridge and would connect to an envisioned road that continued toward New Haven and Hartford and then on toward Boston.

HIGHWAY COMMISSIONER DECLINES TO USE EMINENT DOMAIN TO SECURE LAND

Land purchases for the name-morphing roadway began in 1930. In later documents, highway commissioner Macdonald explained that he and other highway management felt that the courts could award more money through the process of eminent domain than the land agents of the highway department might be able to negotiate. It was also more expedient to purchase the land, and there was significant public and governmental pressure to get the roadway started to alleviate the congestion, blight and pedestrian danger on the Post Road.

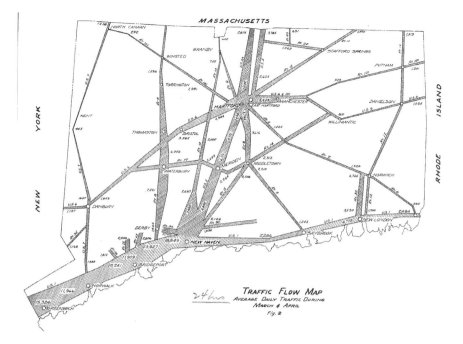

This springtime count shows numbers much lower than the peak period of summer and excludes Sunday. *Courtesy of Connecticut Department of Motor Vehicles.*

Opposite: These were two considered routes of the parkway's eastern path. A portion of the lower route was worked on before the northern route was chosen. *Courtesy of the* Bridgeport Post, *May 20, 1935.*

Commissioner Macdonald was quoted saying that perhaps people would be persuaded to donate land to the Merritt's right of way—a hilarious thought as we look back and see that the Merritt winds through, even then, some of the most precious real estate in Connecticut. The problems with this approach—high-priced real estate and a solo land agent for the highway department—would be Macdonald's undoing.

While the supporters of the Merritt plan were searching for a funding mechanism, Commissioner Macdonald was moving forward on two fronts. All possible planning was executed on the parkway: parcels were purchased and construction was commenced within the department's limited budget. This parkway was done while, simultaneously, the highway department widened the Boston Post Road anywhere possible and made other improvements along the current transportation artery. As is apparent over time, traffic does not decrease as roads widen to accommodate the gridlock.

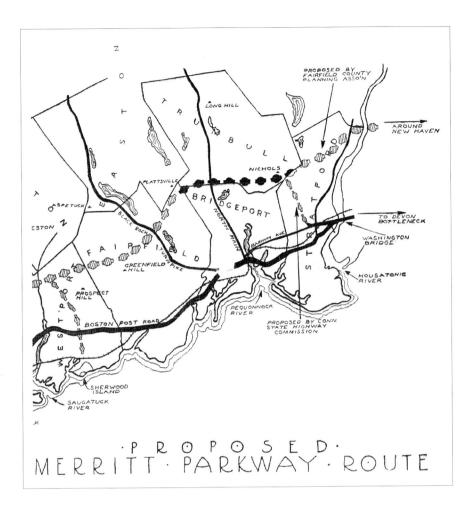

·P R O P O S E D·
MERRITT · PARKWAY · ROUTE

So the redesign and safety improvements continued along Route 1 while the legislators contemplated, strategized and discussed. At one point, in a tongue-in-cheek move, Macdonald introduced, via a representative, a bill in the General Assembly that stated basically that the Merritt wasn't needed now and the Post Road would do. This was quickly and decidedly defeated as citizens and legislators at this point were firmly attached to the alternative road. So perhaps the bill spurred legislators toward action, which was likely Macdonald's purpose.

As the Roaring Twenties came to a close, fifteen million cars were on the road, the Model T had been replaced by the Model A (in 1928) and the United States fell into the Great Depression (in 1929). Soon 25 percent of the nation's workers would be unemployed, and 37 percent of nonfarm

workers would be unemployed. Connecticut found itself with one in three workers un- or underemployed. Moving forward with the parkway project made even more sense, and the possibility of obtaining federal work-relief financing and the prospect of providing jobs helped push the project toward a solution. Connecticut was in the process of embarking on its largest public works project with the potential to employ thousands. And still, while parcels were being purchased, the route was to be kept a "secret" to prevent inflated prices from holdout landowners.

2

THE 1930S

The Work of Creating the Parkway

Car of the Decade: Mercury 8 Touring Sedan
On the Car Radio: "You're Driving Me Crazy" by Walter Donaldson/Rudy Vallee

Since Connecticut and the rest of the nation were suffering from stifling unemployment, it is not surprising that the official "start" of the Merritt Parkway was delayed largely by the financing structure and strategy. However, the highway department started buying parcels in April 1931 and grading (leveling cuts or gullies with fill and bulldozing land obstacles in the parkway's path) portions of the yet unfinalized path with its own department money to the tune of about $6 million before the actual financing structure was identified, approved by the legislature and finalized in 1935.

PLANNING THE ROUTE

The route of the Merritt Parkway, as mentioned, was originally envisioned as an arc of sorts, stretching from Greenwich and ending at the Stratford-Devon Bridge (the George Washington Bridge) that crossed the Housatonic. The first right-of-way parcels were purchased in April 1931—starting at the Greenwich and Stratford ends. Everyone, but particularly planners in Stratford and the FCPA members, realized the immensity and consistency of the bottlenecks that would occur as the additional fast-moving traffic from the Merritt merged to a single eastbound lane over the bridge.

Once reality set in, the original Stratford land purchases en route to the existing Route 1/Housatonic River crossing via the Washington Bridge were ignored, and the already constructed roadbeds were left behind. Also, the necessary "connectedness" of the western end of the parkway to New York's Hutchinson River Parkway (the Hutch) was accepted by the conservative politicians, and the FCPA's strong suggestion of a new northern bridge over the Housatonic, aimed at New Haven and eventually Hartford, was incorporated once the parkway was partially constructed and its wide acceptance foretold more traffic than the town of Stratford or Washington Bridge could handle. Of course, the exact location of the western terminus in Westchester County was not entirely under the county's control—due to holdout landowners—until the parkway's completion in 1935. If it is not readily apparent, there were many simultaneously moving parts in the determination of the ultimate (and changing as needed) route of the Merritt, and there were many challenges, not the least of which was Connecticut's topography. A brief geographic overview of Connecticut and New England shows ridges running north–south separated by rivers and streams. In Fairfield County, no less than eight rivers and numerous streams separate these north–south ridges. The largest river crossing for the Merritt would be at the Housatonic, almost three miles north of the existing bridge carrying Route 1.

Towns immediately weighed in on the route once it was published in the local papers. Wilton and Weston wanted nothing to do with the new roadway. Norwalk was aggrieved that the parkway did not cross its borders (thus a general movement southward). The community of Nichols in Stratford/Trumbull was alarmed about being divided and demolished by the road's path. The Greenfield Hill section of Fairfield demanded no exits, as did the eastern part of Greenwich, initially. In Greenwich alone, at least eight paths were researched, and in other towns, from three to five were investigated: "Practically every suggestion was received with disfavor by those who knew and by those who did not have the slightest idea where the proposed route was to be constructed."[5] The Greenwich Library oral history project has a Merritt Parkway index, with individuals sharing dozens and dozens of "Merritt-related" stories. In those hours of tapes, one can listen to recollections about those estates that sold out or were bisected by the Merritt, and one can discern the "blockers," including a country club, and parcels to be avoided, such as cemeteries. Were the western terminus not fixed by the Hutchinson River Parkway and had there been less resistance in northwestern Greenwich, the unusual curve

north and east might have been different, although in fairness, there simply was more development in that section of Greenwich than there was farther north. The Greenwich Water Company parcel in northwest Greenwich was bisected by the Merritt, making it unusable as a potential reservoir site, and eventually, the divided seventy-five-acre parcel became the property of the local Boy Scouts Council, which named it after resident Ernest Thompson Seton, founder of the Boy Scouts of America. Today, Scouts on a frequently used path cross under the Merritt through a good-sized, exclusively pedestrian and horse tunnel, one of the unusual overpasses of the parkway.

Such extensive research in about fifteen towns required highway bureau employees to research titles, town assessments and taxes. Bureau staff also certified ownership and verified owners' contact information across multiple potential routes through each town. At the same time, surveyors were out on various route options, looking at the lay of the land, waterways, obstructions, structures, rock formations, ledges and topography. This data collection had been going on since 1927, and these statistics were, loosely, the basis of G. Leroy Kemp's negotiations with landowners in the path of the road. But the path chosen was largely determined by Macdonald and based on the surveyors' results, geographic hurdles, two large reservoirs in Greenwich, the Hutch's eventual terminus, wealthy and connected landowners and expediency. The closer the Merritt's path came to town centers and their densely built-up neighborhoods, the more expensive the land and the more landowners involved. The farther north the route was conceived, the more imposing the north–south terrain became and the more the number of water features increased, but this route had less expensive land and less resistance from the inhabitants, generally speaking. Commissioner Macdonald realized early on that there was no pleasing everyone. In the course of purchasing 482 parcels, totaling 2,600 acres, to make way for the Merritt, there were bound to be many irregularities.

Thoughts about allowing exits changed as soon as the grading crews came through; for example, in Greenwich and Stamford when, suddenly, "backcountry" residents were cut off, they realized access to this new road would help them traverse from east to west as well. Meanwhile, during construction and because of some unique topographic considerations, there were unofficial grade level crossings and breaks in the median in Greenwich at Butternut Hollow Road and in Stamford at Den Road, as well as in several other locations initially. All of these aberrations of a limited-access, divided highway were closed off as entrances, bridges and

exits were built. It is worth noting that of more than fifty north–south roads impacted by the limited-access parkway, only about a dozen or so less critical thoroughfares were bisected and terminated on both sides of the Merritt, creating cul-de-sacs out of roadways.

The Fairfield County Planning Association and the Merritt Parkway Commission were unyielding in protecting Fairfield County's resources and property values. The commissioners wanted to play an official role in the planning of the road, just as the highway department and the governor wanted to maintain the status quo of controlling public works projects.

The idea of public ownership of the roadside, as opposed to private ownership along the Post Road, caught the attention of many civic groups, including the Connecticut Forest and Parks and the Federated Garden Club. A bill introduced by Helen Binney Kitchell, a Greenwich state legislator and garden club member, recommended the elimination of all billboards and proposed measures to govern commercial development along roadsides. The aim was to curtail and eliminate the ugly distractions of the Post Road's billboards, gas stations and diners.

COMMON LAW CONSPIRACY

G. Leroy Kemp, a former representative in the legislature from Darien (1927, 1929), experienced real estate agent and Republican, was employed by the Connecticut Highway Department in 1932 as a land agent for the department, replacing Elliott P. Bronson, the original agent who died before starting the job. Kemp became the buying agent who worked with other agents who represented the sellers. Extensive corruption in Fairfield County evolved as Kemp cultivated "collaborative" selling agents. Together they agreed to land sales at inflated prices; inflated prices led to inflated commissions, which they then split. After six years on the job as chief land purchaser for the Merritt's three-hundred-foot right of way, Kemp and eight others would be indicted by a grand jury in Fairfield County for conspiracy and fraud, with three of them—G. LeRoy Kemp of Darien, Thomas H. Cooke of Greenwich and Samuel H. Silberman of Westport—being convicted. Kemp's five counts of common law conspiracy landed him in jail for four years.

In early 1938, Governor Cross responded to incessant, shocking headlines and asked Department of Public Works (DPW) commissioner Robert A.

Hurley (Republican) to investigate the state highway department as a result of these very public corruption cases. Although Commissioner Macdonald was not personally indicted, he was at the helm during the bruising investigation, trials and outraged cries of scandal. Macdonald defended the highway department, calling Hurley's allegations against him and the highway department employees "crudely deceptive and cruelly destructive."[6] After the grand jury announced its findings in April, Governor Cross asked Commissioner Macdonald for his resignation. The yearlong media event ran into and alongside the 1938 opening of the first eighteen miles of the Merritt Parkway.

Beyond the citizens' incredible expectations, project complexity and financial uncertainties, there were also old-fashioned and high-charged political issues at play among the commissioners. For eight months in 1937, until the attorney general stepped in to sort out this particular power struggle, Hurley had finagled control of highway construction by working with the Republican legislative majority. It was only three years later that ambitious DPW commissioner Hurley defeated incumbent Wilbur Cross in the primary and went on to become Governor Hurley. In an interesting twist, previous commissioner Macdonald drove in the first car with the governor at the opening day ceremony over the initially completed eighteen miles on June 29, 1938. It was as if, with some compassion, they somehow knew this roadway was meant to be Macdonald's culminating life work, and duly demoted, perhaps devastated, he would die within a year at the age of forty-nine.

So the theory of purchasing the land for the Merritt at good prices, better than eminent domain, was overshadowed by years of headlines screaming of "immoral, corrupt, dishonest" practices. These scandals were printed next to the stories of grand opening celebrations, speeches, convoys of dignitaries, joyous headlines, financing updates and construction statuses on the state's largest public works project up to that time.

LEGISLATION AND FINANCING

It was perhaps the possibility of obtaining federal financing and the prospect of providing jobs that set the construction of the Merritt in motion at last, among all the other reasons to proceed. "The main thing we've got to work for in the next Legislature is the Merritt highway," county Republican leader

Harry E. Mackenzie said in remarks to party delegates. "We don't know how much it is going to cost but we've got to see it through."[7]

In 1931, the legislature authorized three bills to begin construction of the Merritt Parkway. The route from Greenwich to Stratford was to become part of the state's trunk line of highways (akin to state roads). The designation granted the state control of the road and responsibility for purchasing the right of way, infrastructure construction and future improvements. The second bill passed established the Merritt Parkway Commission. The commission would be appointed by Governor Cross, and in addition, Commissioner Macdonald would serve ex officio. The commission's duties included design and management of the parkway and right of way, establishing traffic regulations and administrating contracts for future sales of gasoline on the Merritt. The last piece of legislation appropriated $1 million annually for acquisition of land and construction to the highway department.

Macdonald asked for a review by the state attorney general of the powers of the commission, as the bill stated authority would begin after construction of the Merritt. The wording of the bill, as it turned out, allowed for wide latitude in its interpretation. However, the attorney general concurred with Macdonald; the commission would not have any power until the Merritt was built. Accordingly, Commissioner Macdonald remained in control in the development and building of the Merritt, but disappointment did not deter the commission from advocating for "a parkway and not a highway."

Progress on the Merritt remained sluggish, and it quickly became apparent that the completion of the highway would take ten years given the $1 million annual appropriation toward the project. At the time, Connecticut did not believe in issuing bonds to pay for public works projects, and the legislature rejected any sale of state bonds for the Merritt. However, in 1935, the General Assembly authorized a bill for Fairfield County to sell $15 million in bonds. The bill was passed with the belief that the application for federal funding would be approved. It appears the Public Works Administration (PWA) and the Works Progress Administration (WPA) could not agree on funding the project.[8]

It was unthinkable that construction of the Merritt would not be federally funded, as this was one of the largest public works projects in New England at the time. The inability of federal bureaucracies to resolve the issue was frustrating. "It was expected federal funds would also be added to help construct this much needed highway," the 1935 *Greenwich Town Report* groused,

Merritt Parkway Construction Costs			
	A	B	C
Acquisition of Property	$4,359,320.86	$ 2.547,630.78	$ 6,906,951.64
Contract Work	1,754,807.95	9,335,195.71	11,090,003.66
Cement	16,231.46	-------	16,231.46
Other State Furnished Materials	5,424.15	8,668.84	14,092.99
Traffic Control	3,412.60	6,296.43	9,709.03
Property Damages	21,431.65	6,195.79	27,627.44
Work by Maintenance Forces	532.87	9,346.86	9,879.73
Roadside Development	158,773.86	1,420,825.97	1,579,599.83
Work Under Supervision of the Construction Engineers	1,288.98	49,028.13	53,317.11
Engineering	233,721.51	622,644.97	856,366.48
Advertising	1,271.60	10,262.28	11,533.83
Gasoline Stations	-------	16,688.11	16,688.11
	$6,559,217.49	$14,032,783.82	$20,592,001.31

A – Paid from Highway Fund Prior to Bond Issue
B - Paid from Bond Issue
C – Total Payment to August 31, 1940

*Includes $438,077.07 from P.W.A.

An additional $2, 100,000 was incurred on bond interest

The total cost of the Merritt Parkway as presented by the Connecticut Highway Department. *Connecticut State Library in Weld Thayer Chase Collection.*

"but a section where the tax money comes from was neglected in favor of the Florida Ship Canal and the Passamaquoddy tide harnessing scheme." There are also newspaper reports and recollections that the financing everyone expected for the Merritt went instead to a new road through the Smoky Mountains, to pass through a park. There was speculation that with the defeat of the incumbent Democratic governor Wilbur Cross, the Democratically controlled U.S. Congress was motivated by some form of political payback in the loss of those WPA funds for Connecticut. Or perhaps Roosevelt himself recalled the negative light in which Congressman Schuyler Merritt painted the president of the opposite party.

CLEARING FOR THE PARKWAY

Clearing the three-hundred-foot right of way was a complex orchestration of machinery and men. Inspectors from the Connecticut Highway Department Bureau of Roadside Development would walk the area and decide which trees and vegetation needed to be cleared or, whenever possible, save

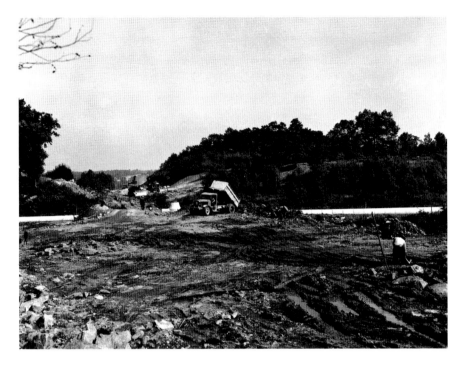

Drainage pipes were installed prior to trucks delivering fill for the roadbed. *Courtesy of George L. Larned Collection, Library of Congress, HAER CONN,1-GREWI,2—76.*

Workers dug gravel for road fill. This pit eventually became Toll Gate Pond in Greenwich. *Courtesy of Weld Thayer Chase Collection, Connecticut State Library, RG 69:036.*

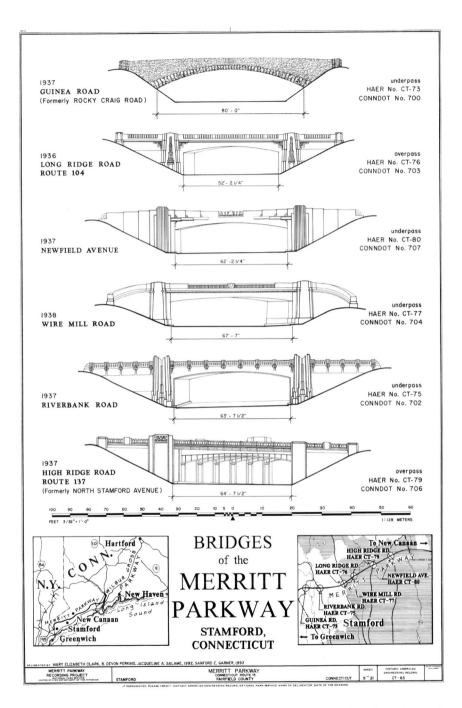

Shown are varying architectural styles and treatments of six bridges in Stamford. *Courtesy of Library of Congress, HAER CONN, 1-GREWI, 2-(sheet 5 of 21).*

healthy specimens for future plantings. Some trees were tagged to remain in their current location while others were cleared to open vistas. Trained foresters directed the contractor's logging operations. In addition to clearing, "stumps, dead trees and general debris are removed and burned to improve the appearance of the wayside."[9] Loam and topsoil were stockpiled to help reestablish plantings after construction.

Unlike the Westchester County parkways, the east–west alignment of the Merritt cuts through the north–south natural terrain. Deep cuts into the ridges and deep filling of the valleys were necessary to avoid a roller coaster–like driving experience. The work was exhausting, as described by Commissioner Macdonald: "Gangs of 24 men would work in shifts using dynamite, power-shovels, trucks and bulldozers to remove the rock ledges."[10]

The rock ledges were moved to locations requiring fill. Instead of purchasing additional fill, a quarry was created in Greenwich on an unattractive tract of land. When construction activities were completed, water was diverted from the Byram River, creating Toll Gate Pond. At the end of the project, about five million cubic yards of earth and rock were excavated, making this one of the largest rock grading projects in New England.

Man-made structures needed to be razed or relocated to accommodate the route. According to Commissioner Macdonald, this included one church, a greenhouse, a studio, a shop, three stables, twelve garages, thirteen barns, fifty-one houses and thirty-two other buildings. If this weren't enough chaos, the press reported on activities in addition to the busy construction work site:

> *Students of geology have been busy through the progress of the job studying strata and collecting quartz crystals, garnets and other specimens. Several hundred pounds of honey were found in a tree after it had been cut down, and one of the workmen who took home a chunk containing dormant bees arrived at work the next day with a fine assortment of bee stings, acquired by fighting bees which thawed out in the warmth of his kitchen.*[11]

Impromptu trout fishing contests among the workers were popular, with men vying for the biggest catch of the day. And on more than one occasion, the workers entertained themselves with greased pig races. Construction was also periodically interrupted by the occasional foxhunt.

PARKWAY DESIGN

The Merritt was designed for an efficient, pleasurable and safe driving experience based on an "exhaustive study of parkways already constructed in America and abroad."[12] The design was based on highway principles, popular in the 1930s, that stressed safety, including separation of opposing traffic with a median. Grade separations with existing roads, railways or waterways are engineered with bridges crossing over or under the Merritt, eliminating intersections. Planned entrances and exits prevented access from frontage roads. The landscape was to be composed of native species, without billboards. The road was designed for noncommercial traffic, a point Schuyler Merritt spoke of at the 1934 groundbreaking ceremony: "This great highway is not being constructed primarily for rapid transit but for pleasant transit. This county is fortunate in having such beautiful backcountry and it is our great duty to see that these beauties are preserved."[13]

On the Merritt, each of the two roadways was designed to be twenty-six feet wide and separated by a twenty-one-foot-wide landscaped median that narrowed under the bridges. Landscaping of the medians was for both beautification and safety, as the plantings screen oncoming headlights at night and again "break the monotony of day travel."[14]

The geometry of the thirty-seven and a half miles of the Merritt through the open countryside consists of forty-six expansive curves, banked for safe travel speeds of up to forty-five miles per hour, disbursed between the straightaways.[15] The road has an average grade of 4 percent and a maximum of 7 percent. The ratio of 16 percent of curved road and 84 percent of straight road was planned to make the drive more engaging.[16] The curves and hills provided for a dramatic driving experience with panoramic views of the surrounding landscape.

All of the crossings are grade separated, reducing accidents and eliminating the need for traffic signals. In 1938, the *Bridgeport Telegram* reported the 62 miles along Route 1 from Bridgeport to the Holland Tunnel "boasted 108 traffic lights," including 66 that were red. With the completion of the Merritt and adjoining Wilbur Cross Parkway, a Shell motor oil print advertisement raved the "only stop sign in 52 miles" was the Greenwich toll booth. "On the Merritt Parkway at Greenwich, you stop to pay your dime—then go!" it read. "This miracle road, engineered for sustained speed with safety, sweeps you on over the hills of Connecticut—only one pause in the 52 miles from Westchester's Cross County Parkway to the fringes of New Haven. What a change from the drive out of New York a few years back."

During construction and even at the end, there were a few controversial at-grade crossings. When state highway commissioner William J. Cox announced the construction of bridges crossing the Merritt at Lake Avenue in Greenwich and Den Road in Stamford, at an estimated cost of $50,000 each, there were accusations that one of the bridges was "planned for the convenience of cows." The owner of the cows had had a special permit to stop traffic for the cows to cross the road at grade until there was a bridge. Obviously there was a safety issue with cows crossing the Merritt, with or without a permit. Commissioner Cox denied the bridge was built merely for the convenience of cows.

Additional safety features included a concrete, paved surface with a rough finish to reduce skidding under normal travel conditions, mountable curbs on both sides of the road and glass reflector button "cat eyes" on the outer road edge to assist drivers at night. The four-and-a-half-foot grass shoulders allowed drivers to safely pull over and provide "elbow room" for vehicles to avoid accidents.[17] Surface drainage included a network of storm sewers and catch basins, which drained to culverts in the right of way.

Bridge Construction and Bridge Design

The Merritt was entirely planned and designed in-house by the Connecticut Highway Department. Commissioner Macdonald supervised the tightknit circle of engineers and roadside development architects. There were numerous remarkably talented individuals working on the project, with the notable Arthur W. Bushell and Warren M. Creamer contributing to the planning of the route and the construction design. John Willis and Leslie G. Sumner supervised the structural engineering.[18]

Leslie Sumner began working at the Connecticut Highway Department after graduating from Yale University in 1915. The design of the bridges required a balance of economics, functionality and beauty. Sumner felt the bridges should not be "strictly utilitarian structures…One reason for this is that the route usually passes through country of some natural beauty which should not be marred by the more unfortunate work of man."[19]

The majority of the bridges on the Merritt are rigid-frame bridges. Rigid-frame bridges were originally designed by German engineers and used by Brazilian engineer Emilio Baumgart. The Bronx Parkway Commission first used them in the United States in the 1920s.[20] The Merritt's rigid-

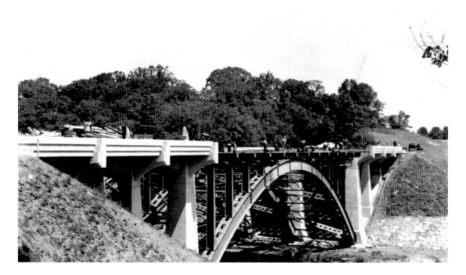

Saugatuck River Bridge in Westport was the most challenging bridge to construct due to topography and ledge. *Courtesy of Connecticut Department of Transportation Collection, Library of Congress, HAER CONN,1-WESP, 12—11.*

frame bridges are mostly designed with a deck slab connected to abutment walls and, in some instances, pier columns. Adjoining wing walls allow the backfilling of soil to support roadways. Rigid-frame construction allows the different elements to be constructed as a single unit.

The rigid-frame construction was advantageous as such bridges are less expensive to build, given that not as much concrete and steel are needed compared to traditional post-and-beam or arch styles. The rigid-frame design was also stronger, allowing for additional carrying capacity.[21] Leslie Sumner recognized the Merritt was limited to automobiles and yet designed all the bridges for truck traffic: "Also, unforeseen emergencies or change in policy may later require the road to carry commercial traffic." This proved to be the case during the Second World War, when military traffic was permitted.

An additional economic requisite eliminated the stone facing on the bridges. When Macdonald announced the bridges would be faced in concrete and not stone, "disapproval was quickly voiced." It was estimated that stone facing of the bridges would be an additional $9,000 per bridge. Citizen groups, including the garden clubs, Greenwich Woman's Republican Club,

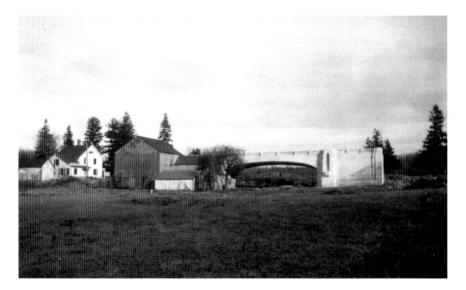

Sometimes the complexity of the project resulted in a bridge being built before the road arrived, as was the case for Sport Hill Road Bridge in Fairfield. *Courtesy of Weld Thayer Chase Collection, Connecticut State Library, RG 69:036.*

bridge would fit into the landscape and not detract from the natural surroundings. In areas where the land was flatter, horizontal design lines were emphasized, and in hilly or rocky areas, vertical lines were emphasized. Light, shadows and angles were noted prior to preparing a series of design sketches.[26]

After the sketches were prepared, they were distributed to other staff members for comment. Dunkelberger notes this process:

> *The drawings are passed around the office and subjected to many criticisms and suggestions; after which the designer feels that he should never have taken up architecture as a profession. Successful design being a matter of opinion, the criticism of the average person is of great value inasmuch as the majority of people who will see the structure are not college professors, architects, or engineers.*[27]

Dunkelberger, described by his associates as a "charming, talented character," was a skilled draftsman as well as an artist, musician and designer. Because of his creativity in exploring the plasticity of concrete and bold choices incorporating a multitude of architectural styles,

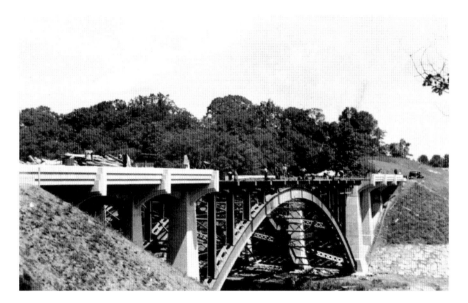

Saugatuck River Bridge in Westport was the most challenging bridge to construct due to topography and ledge. *Courtesy of Connecticut Department of Transportation Collection, Library of Congress, HAER CONN,1-WESP, 12—11.*

frame bridges are mostly designed with a deck slab connected to abutment walls and, in some instances, pier columns. Adjoining wing walls allow the backfilling of soil to support roadways. Rigid-frame construction allows the different elements to be constructed as a single unit.

The rigid-frame construction was advantageous as such bridges are less expensive to build, given that not as much concrete and steel are needed compared to traditional post-and-beam or arch styles. The rigid-frame design was also stronger, allowing for additional carrying capacity.[21] Leslie Sumner recognized the Merritt was limited to automobiles and yet designed all the bridges for truck traffic: "Also, unforeseen emergencies or change in policy may later require the road to carry commercial traffic." This proved to be the case during the Second World War, when military traffic was permitted.

An additional economic requisite eliminated the stone facing on the bridges. When Macdonald announced the bridges would be faced in concrete and not stone, "disapproval was quickly voiced." It was estimated that stone facing of the bridges would be an additional $9,000 per bridge. Citizen groups, including the garden clubs, Greenwich Woman's Republican Club,

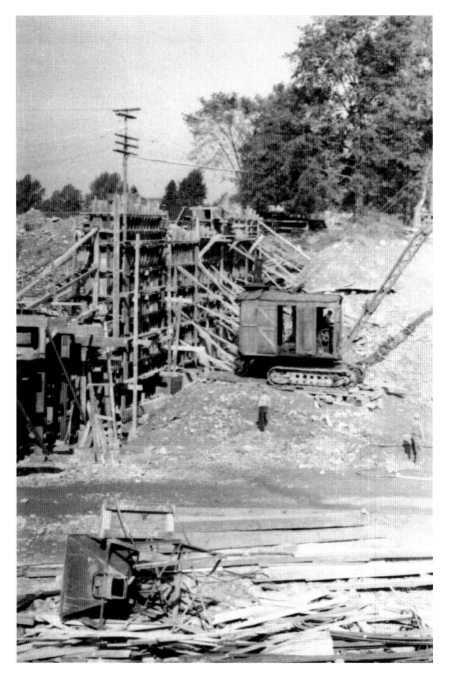

Deluca Construction Company built the wood frame for a wing wall prior to pouring concrete. *Courtesy of the Deluca family.*

the FCPA and the Merritt Highway Commission, demanded stone bridges, or stone-faced bridges, akin to those on the Hutch. Kitchell expressed displeasure with the decision: "No matter how well planted and screened the concrete may be it is not possible to make it conform to the wooded, rocky countryside."[22]

Commissioner Macdonald left the decision up to the towns—if they wanted stone-faced bridges, they would bear the cost, but no additional funding would come forth. Two bridges would be stone faced at the highway department's expense (Guinea Road in Stamford and Main Avenue in Norwalk), and there was a last-minute change to stone face a third bridge carrying the parkway over Rippowam River in Stamford. (This bridge is called an overpass since the parkway is carried over this bridge.) Gutzon Borglum, sculptor of Mount Rushmore and Stone Mountain in Georgia, refused to sell his property in Stamford if the planned bridge in his view shed was not faced in granite. Borglum threatened legal action. In the end, Macdonald agreed to the stone-faced bridge, as "it was a case of making the agreement, or spending more money fighting to get the land."[23]

The next challenge was bridge design, a monumental task taken up by architect George Dunkelberger. Born in Camden, New Jersey, in 1891, Dunkelberger attended the Drexel Institute of Art, Science and Industry and Industrial Art School in Philadelphia. He worked for several architectural and engineering firms in Philadelphia and Hartford. After returning from World War I, he opened an architectural firm with Joseph Gelman in Hartford designing homes and apartment buildings. The firm was closed during the Depression, and he was hired in 1933 at the Connecticut Highway Department as a junior draftsman. In 1935, Dunkelberger was given the responsibility of designing the Merritt Parkway's bridges. He explains:[24]

> *In designing the bridges for the Merritt Parkway I was impressed with the fact that the Connecticut State Highway Department was seeking to accomplish in concrete what other states have done in stone, which naturally is a matter of no small moment when we consider what type of bridge would ordinarily be suitable for the average trunk line highway. Obviously, each bridge must express individuality and also be designed in such a manner that the final result would be an asset rather than a liability.*[25]

The most important measure in the success of a bridge's design was the site inspection, as location dictated the design. Dunkelberger gave careful thought to the bridge aesthetics and placement so that the

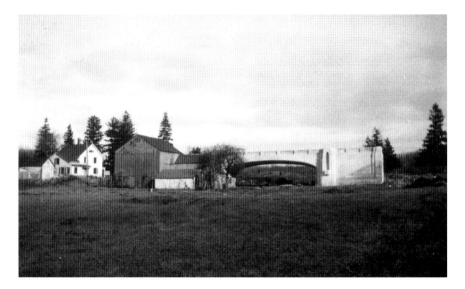

Sometimes the complexity of the project resulted in a bridge being built before the road arrived, as was the case for Sport Hill Road Bridge in Fairfield. *Courtesy of Weld Thayer Chase Collection, Connecticut State Library, RG 69:036.*

bridge would fit into the landscape and not detract from the natural surroundings. In areas where the land was flatter, horizontal design lines were emphasized, and in hilly or rocky areas, vertical lines were emphasized. Light, shadows and angles were noted prior to preparing a series of design sketches.[26]

After the sketches were prepared, they were distributed to other staff members for comment. Dunkelberger notes this process:

> *The drawings are passed around the office and subjected to many criticisms and suggestions; after which the designer feels that he should never have taken up architecture as a profession. Successful design being a matter of opinion, the criticism of the average person is of great value inasmuch as the majority of people who will see the structure are not college professors, architects, or engineers.*[27]

Dunkelberger, described by his associates as a "charming, talented character," was a skilled draftsman as well as an artist, musician and designer. Because of his creativity in exploring the plasticity of concrete and bold choices incorporating a multitude of architectural styles,

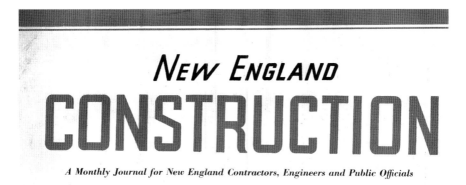

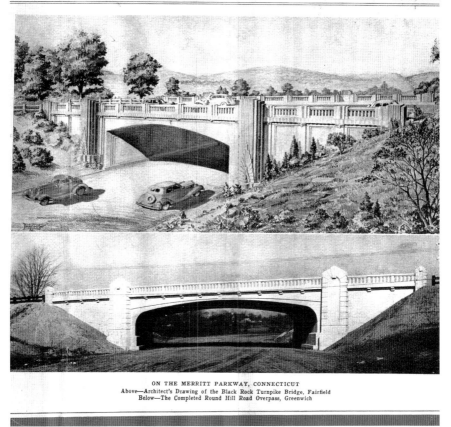

ON THE MERRITT PARKWAY, CONNECTICUT
Above—Architect's Drawing of the Black Rock Turnpike Bridge, Fairfield
Below—The Completed Round Hill Road Overpass, Greenwich

Dunkelberger was not only an architect but also a true artist, as shown on this magazine cover. *Greenwich Historical Society.*

each bridge is unique. One urban myth states that students at Yale's architecture school designed the bridges. A second claims there was a competition for each bridge design. However, each of the seventy-two bridges, divided into thirty-seven overpasses and thirty-five underpasses, was designed by Dunkelberger.[28]

Dunkelberger's holistic designs treated the bridge as one continuous structure. The expansion joints, between the frame and wing walls, were exposed and became part of the design, accommodating ease of construction. The wing walls were used as an opportunity for decoration and to connect the arch into the overall design. The railings, pylons and legs were also blended into the design.[29] Additionally, the concrete surface "must depend for its effects upon contrasts, the casting of shadows, and well chosen details and ornaments in addition to a careful balancing of the essential features, all of which requires considerable study and good judgment on the part of the designer."[30]

The bridges integrate strong form and distinct ornamentation. The Art Deco style of the Long Ridge Road (Stamford) and South Avenue (New Canaan) bridge pylons are decorated with fountains the style of which was introduced at the Paris *Exposition Internationale des Arts Décoratifs et Industriels Modernes* in 1925.[31] The River Bank Road Bridge, with its striking pylons, was influenced by the Moderne architectural style popular in 1930s buildings. The dramatic design was criticized by Museum of Modern Art critic Elizabeth Mock: "This rigid frame of reinforced concrete apes no historical precedent. Its vulgar ornament is peculiar to our times and easy of achievement in this docile material."[32] Of course, this bridge also has many fans.

Other architectural influences include modern classicism, used in federal government projects in the 1930s. The Sport Hill Road Bridge is representative of this style, a single-span bridge with the abutments decorated. The stone-faced Guinea Road Bridge can be described as Rustic. Late Gothic Revival influences the New Canaan Avenue Bridge, and the concrete-cast Newtown Turnpike Bridge is French Renaissance Revival.[33]

The goal was perhaps best articulated by Commissioner Macdonald: "In the design of the bridges an effort has been made to depart from the accepted types and styles of architecture so generally used on structures of this sort."[34]

Ornamentation

The individual character of the bridges was further enhanced to "relieve the monotony" of a series of concrete bridges. Dunkelberger's imagination and genius were apparent in his understanding of the adaptive nature of concrete and use of surface treatments to add color and texture. Additional aggregate, pigmentation, sculpture and molding were added to relieve the uniformity of the concrete surfaces. Not all of the work was done on site at the bridges, as is the case with the Long Ridge Road Bridge (Stamford) and South Avenue Bridge (New Canaan). The fountains and sunbursts were precast in the studios of Edward Ferrari in New Haven and brought to the sites to be affixed to the bridge framework. The double arch opening of the James Farm Road Bridge (Stratford) anchors the iconic wing sculptures. Concrete workers doubted if the alignment could be achieved—and to Ferrari's credit, it was a perfect installation.

Edward Ferrari was the son of artist Febo Ferrari, sculptor of the nineteen figures in the Delafield Memorial Parapet of the Cathedral Church of St. John the Divine in New York City. Edward attended Yale University's School of Fine Arts and graduated in 1926. He worked for private concrete companies sculpting architectural ornamentation for buildings. In 1935, Ferrari began his collaboration with George Dunkelberger on the Merritt Parkway bridges. Their partnership lasted until 1941. During World War II, Ferrari worked as an industrial sculptor making models of aircraft parts at Chance Vought Aircraft. In 1947, realizing "sculpting embellishment for building and bridges—was dead," he went to work for General Electric in their design department making clay models of their small appliances that would "revolutionize American life."[35]

Dunkelberger would provide detailed drawings of the decorative embellishments to Ferrari. "George was not a plain architect, but primarily an artist. He drew, and drew well. That made it easier. He knew what he wanted. People have to be compatible…with George and me, there was very little conversation. He'd bring a sketch, we'd talk a little, and we did it. That was it. It was a collaboration," he said.[36]

Ferrari would study Dunkelberger's drawings and then sculpt the clay models to be cast in stone or metal. Ferrari only took credit for the "technical expertise and proficiency in the sculpture," as Dunkelberger's drawings were so detailed. The eclectic ornamentation ranges from his panels dedicated to the surveyors and construction workers on the Burr Street Bridge (Fairfield) to the often-used Connecticut state coat of arms,

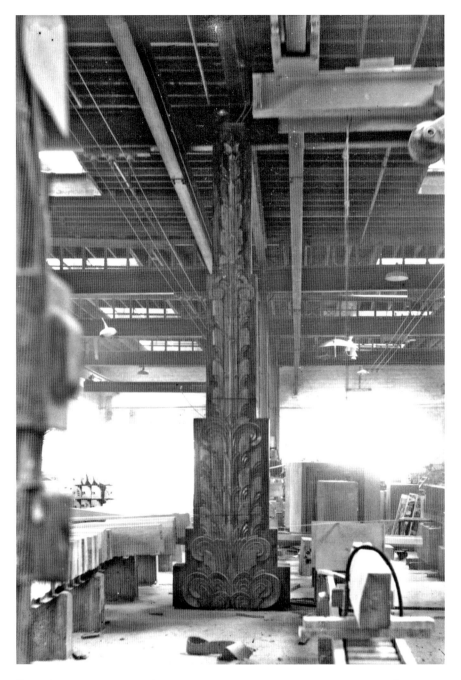

Shown is a concrete casting of a bridge ornamentation in the New Haven shop of Decorative Stone Company. *Courtesy of Marguerite Shuck and Catherine Lynn.*

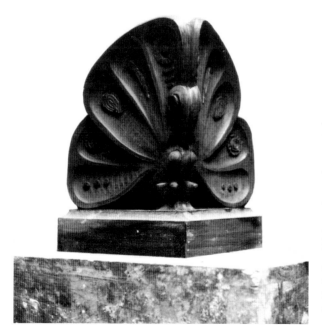

Above: This relief on the Burr Street Bridge in Fairfield is an artistic salute to the construction workers on the parkway. *Courtesy of Marguerite Shuck and Catherine Lynn.*

Left: This clay model of a resting butterfly waits to be cast in concrete for the eight abutment corners of Merwin's Lane Bridge in Fairfield. *Courtesy of Marguerite Shuck and Catherine Lynn.*

as on the Newfield Avenue Bridge (Stamford), and to the flora and fauna details found along the parkway.

Cast iron and malleable cast iron provided additional design possibilities, including the playful Merwins Lane Bridge (Fairfield) railing of spider webs and butterflies, the bold flowers on the Main Street Bridge (Stratford) and the grapevine grills on the Lake Avenue Bridge (Greenwich).[37]

Reverse molds, or waste molds, were poured into the framework of the bridge and hardened in place. This process ensured the ornamentation would match the color of the bridge concrete when desired, as precast ornaments' color could differ from the bridge's. Great care was needed in designing the molds to eliminate undercutting, which could damage the ornamentation when the mold was removed.[38] The owls on Hillside Road Bridge (Fairfield) and the Pilgrim and Indian panels on the Comstock Hill Road Bridge (Norwalk) were created using reverse molds.

Sgraffito designs were used to decorate the façades and pylons on the bridges. This was a process of layering lighter colors of concrete and then scoring the top layer to expose the darker bottom layer. The North Street Bridge (Westport) pylons and the griffins on the High Ridge Road (Stamford) and the Grumman Avenue Bridge (Norwalk) were achieved using the sgraffito process.[39]

In some cases, formwork was used to decorate the entire bridge. The gridlike grooves of the Morehouse Drive Bridge (Fairfield) give the appearance of large blocks or tiles. The Merwins Lane Bridge (Fairfield) wing walls appear to be overlapping clapboards. Cast stone, an effect resulting from one type of form work, mimics real stone on the bridges and was used because it was less expensive and did not require skilled masons for laying. The Frenchtown Road Bridge (Trumbull) and Newtown Turnpike Bridge (Westport) are examples of cast stone. However, the Guinea Road Bridge (Stamford) is a combination of real and cast stone.

The coloring of the bridges was achieved by mixing the cement with aggregate and mineral pigments. "Glass shards, metal chips, mosaic cube and mother-of-pearl were used to achieve a reflective surface" during the day and at night. Merwins Lane Bridge (Fairfield) was tinted green; Clinton Avenue Bridge (Westport) had diamond-patterned panels that were red. Unfortunately, the colors have disappeared after being exposed to the weather.[40]

None of Dunkelberger's designs could have been executed without talented and skilled workers. Dunkelberger states:

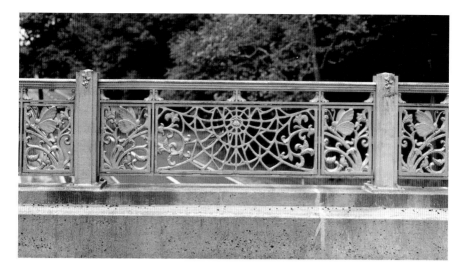

This cast-iron railing of butterflies and spider web with the waiting spider faces the travel lanes. Merwins Lane Bridge, Fairfield. *Courtesy of Library of Congress, HAER CONN, 1-FAIRF,24—5.*

Ferrari's model of griffins and the Connecticut state shield awaits installation in the New Haven studio. High Ridge Road Bridge, Stamford. *Courtesy of Marguerite Shuck and Catherine Lynn.*

Ferrari's ornamentations were installed on Merwins Lane Bridge in Fairfield. *Courtesy of Library of Congress, HAER CONN, 1-FAIRF,24—4.*

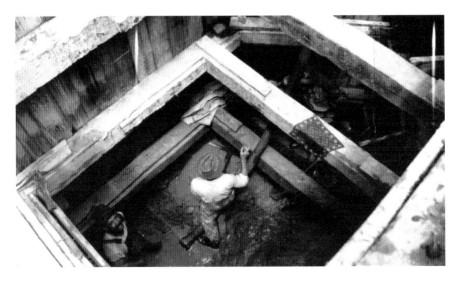

"I never knew a man who worked on the Parkway that did not have a sense of what we were trying to do. They felt they were really making a contribution to Fairfield County and the Nation," said Earl Wood. *Courtesy of the Deluca family.*

One thing of vital importance in the successful production of the finished work is the education of the contractor in work of this character. The average contractor, at least from my experience, not being familiar with these methods, must be made to realize that care must be used at all times to prevent injury to the different types of material incorporated in the Merritt Parkway bridges. It is not just a case of filling a form with concrete, for the simple reason that forms are more intricate, precast material is harder to handle, and moulds more difficult to set.

Dunkelberger noted the bridge contractors were full of cooperation and willing to assist in making the project an "outstanding accomplishment, which for all time will be a source of pride and a lasting credit, not only to the Connecticut Highway Department, but to our State as well."[41]

LANDSCAPING

The Merritt Parkway captured the beauty of Connecticut's surrounding landscape and drew the traveler into nature with fleeting views of farms, woodlands, lakes and rivers. The landscape architect credited with the design of the parkway's environment is Weld Thayer Chase. Chase attended the Graduate School of Landscape Architecture at the University of Massachusetts from 1931 to 1933. With job prospects bleak during the Depression, he traveled by bicycle through Britain and Europe, staying with the curator of Kew Gardens during the summer and fall of 1933. His "Park Tour" gave him the opportunity to study the naturalistic gardens that influenced Frederick Law Olmsted and other park designers in the United States.[42]

Upon returning to Rhode Island, he landed a job with the Bureau of Roadside Development, an early name for the landscape architecture division, within the state highway department as a junior highway engineer. This was in February 1935. The goal of the Bureau of Roadside Development "was to add to the safety and pleasure of state highways while decreasing the cost of maintenance, increasing the value of adjacent property, and promoting the beauty of the state."[43] A. Earl Wood, Chase's eventual supervisor and the Merritt's engineer for roadside development, quickly recognized his talent for designing a landscape that remained as natural as possible. Chase was influenced by Olmsted and used the principles of preservation and restoration that were included in the Federal Bureau of Public Roads

programs. In addition, he studied the work of Gilmore Clarke, landscape designer of the Westchester parkways.

Chase worked out in the field, referring to the twenty-four- by thirty-six-inch engineering plans, making notes and sketches on the plans that included existing vegetation, size and location of trees, soil conditions, drainage and general character of the area. His designs were then drawn over the engineering plans. In some instances, miniature models of the parkway landscape were constructed at the field office in Trumbull to be reviewed by the landscape team.

Chase's planting plans were designed in harmony with the surrounding landscape. Generally, the intent was to supplement the existing vegetation with the same species or with species that would maintain the character of the existing landscape. This was achieved by planting small clusters of "one to five trees at irregular intervals in the landscape." Trees were planted along the right of way and median at uneven distances, avoiding a formal row of plantings.[44]

The scenic qualities of the surrounding area were leveraged by clearing swaths of vegetation, opening views to the rolling countryside, farms, rivers and occasional glimpses of Long Island Sound. Chase punctuated the seasons, adding color in the winter with evergreens, dazzling fall drivers with deciduous trees and welcoming spring with blooming mountain laurels, dogwoods and rhododendrons.

The bridge plantings were carefully planned so as not to detract from the architectural treatment of the bridge. Low-growing shrubs or ground cover were planted on the abutments, and larger trees framed the ends of the wing walls. Other steep slopes on the parkway were treated with low-growing plant materials or sod to stabilize the soil. For the exposed raw rock ledges, a combination of black birches and vines were planted to hide the blasting damage.

The median plantings were complicated because they needed to provide a continuation of the landscape and prevent the parkway from appearing to be two different roadbeds. Also, plantings had to avoid blocking sightlines and yet had to create a buffer from oncoming headlights. The root systems of the trees could not compromise the extensive drainage system under the median. The median was punctuated with the mature trees saved prior to construction, with clusters of small trees, shrubs and grass.[45] Earl Wood described the scheme as "a sprinkling of trees here and there to break up the sameness and repetition of the greensward."[46]

"To heal the scars of construction," Chase used native trees and shrubs, including pine, dogwood, elm, tulip, oak, cedar, maple, locust, rhododendron,

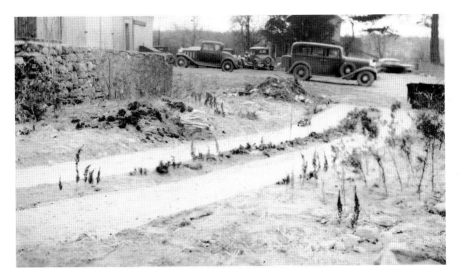

Exhibiting considerable attention to detail, Weld Thayer Chase made scale models of the designed landscape prior to installation. *Courtesy of Weld Thayer Chase Collection, Connecticut State Library, RG 69:036.*

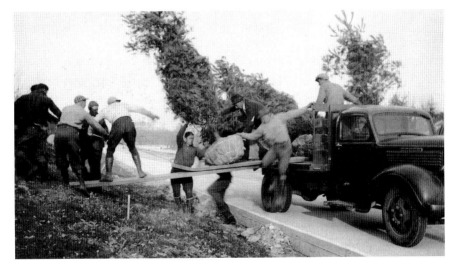

Without the assistance of machinery, crews of workmen carefully moved thousands of trees. *Courtesy of Weld Thayer Chase Collection, Connecticut State Library, RG 69:036.*

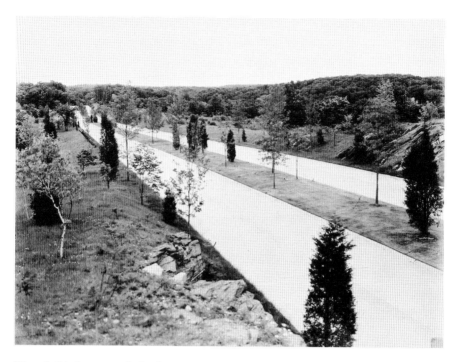

Thoughtful placement of plantings was envisioned to frame vistas into the countryside. *Courtesy of Library of Congress, HAER CONN, 1-GREWI,2—87.*

birch and mountain laurel. Of the nearly 70,000 trees and shrubs required to landscape the parkway, 47,700 were mountain laurel. Plants were purchased from Connecticut nurseries or saved prior to construction and stored at the highway department nurseries. The Bureau of Roadside Development dispatched crews across the state after being notified of plant materials available at other construction locations, on state- and town-owned properties and at parks to transplant them to temporary nurseries. Many organizations, Fairfield County garden clubs and individuals donated plants for the parkway.[47]

As Chase stated, "My aim was to heal the landscape so Dame Nature could pull it together in time."[48] The blending of the road and countryside was seamless, inviting thousands of drivers to experience the beauty of Fairfield County.

Opening

June 29, 1938, was the date set for the opening of the Merritt Parkway, from the Greenwich/New York line to Norwalk, with more than four hundred dignitaries and officials from Connecticut and New York in attendance. The first of four ceremonies began in Norwalk with a ribbon cutting and remarks from Governor Cross. The gold-plated scissors were made by Acme in Bridgeport. From Norwalk, the procession of 140 automobiles stopped for additional ribbon cuttings in New Canaan and Stamford, finally arriving at the King Street Bridge in Greenwich two and a half hours later. Thousands of people attended each of the ceremonies or watched the procession from the bridges. Another one thousand people were waiting in Greenwich for the official ribbon cutting that would join the Hutchinson River Parkway and the Merritt.[49]

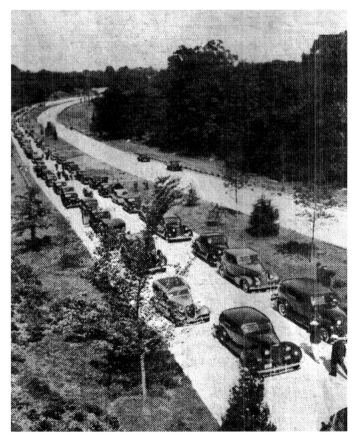

Opening-day ribbon cuttings took place in Greenwich, Stamford, New Canaan and Norwalk. *Courtesy of Greenwich Historical Society.*

The remaining portion of the parkway was opened in three sections, none with as much celebration as the 1938 opening. The Norwalk to Westport portion opened in December 1938. A year later, the Westport to Trumbull section opened, and in September 1940, the remaining portion of the Merritt was connected with the Housatonic River Bridge.

3

THE 1940S

As the Great Depression Fades, Delight in the Merritt Interrupted by World War II

Car of the Decade: Buick Roadmaster
On the Car Radio: "Sentimental Journey" by Les Brown and Doris Day

The Depression had started to recede in the beginning of the 1940s, particularly once the nation started to re-arm. The World's Fair had opened in 1939 hosting millions of visitors. A diorama of the Merritt Parkway was displayed, with its whimsical bridges and leading-edge cloverleaf ramp design. Norman Bel Geddes's Futurama Exhibit and conveyor-belt ride at the World's Fair showed the movie *New Horizons*, which features a shot of cars traversing the Merritt Parkway under the Guinea Road Bridge (then called Rocky Craig Road). The movie's theme was one of great hope, innovation, productivity in all walks of life and progress. Thirty thousand visitors a day came to the Futurama. Between these two exhibits, the nation and the world met the Merritt Parkway; it was the pride and joy of the state of Connecticut.

By September 1940, Fairfield County had its fully completed new road and scenic alternative to the Post Road. Stories of young romance abounded—cars being driven slowly, side by side, connected by sweethearts holding hands; romantic drives through the country; playful trips from the Merritt to Connecticut beaches. In the summer of 1940, parkway landscaping continued with donations from various civic groups. Newspapers throughout the county continued to cover every event involving the parkway. The *Greenwich Press*, for example, reported, "Within the next month, the most extensive roadside

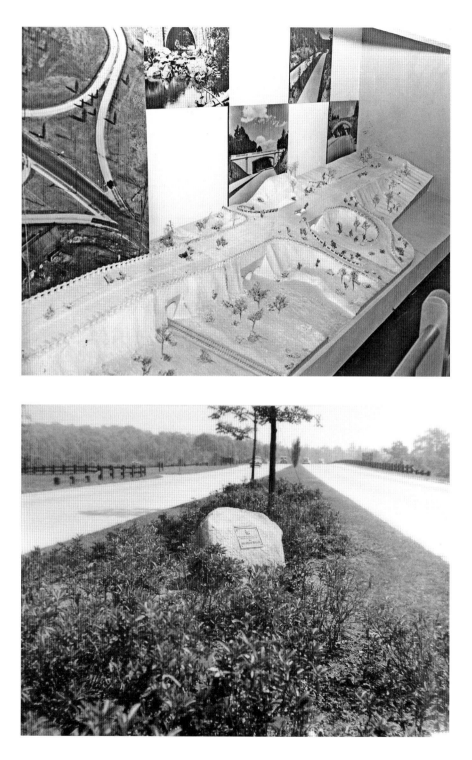

Opposite, top: At the 1939 World's Fair, the "World of Tomorrow," the nation was introduced to the Merritt Parkway in two different pavilions. *New York World's Fair 1939–40 records, Manuscripts and Archives Division, New York Public Library, Astor, Lenox and Tilden Foundations.*

Opposite, bottom: This was one of at least seventeen plaques on the Merritt that recognized civic group and garden club donations. *Courtesy of Library of Congress, HAER CONN, 1-GREWI,2—87.*

Above: For speed of installation and to keep costs below the $1 million financing bond, an open grate span was used over the Housatonic River. *Courtesy of Stratford Historical Society.*

beautification program ever attempted in Connecticut will get under way. Greenwich is represented among the ten Fairfield County garden clubs and civic organizations which will donate several thousand laurel and dogwood plants for planting along the Merritt Parkway."[50]

Citizens were enthused about helping out in small and large ways, for there was great pride in being associated with the Merritt Parkway project. Landscaping donations were solicited, organized and planted with citizens' help. Plaques were erected throughout the participating towns to honor these collaborations.

Generations later, children and grandchildren would come forward and explain just how important the opening of the Merritt was to their families: a needed job, a delightful escape, fall colors and spring blossoms, a Sunday family tradition, access to home ownership further from a job location, the joy of the golden age of the automobile, a new love affair with the road.

But what of the trucks left rumbling along the Post Road? Almost as soon as the extensive Post Road improvements and the Merritt were completed, there was speculation and talk for years of a truck alternative that would run east–west, likely to be south of the Post Road. Of course, once the proposed route was made public (as far as Westport in 1944), the opposition began. Eminent domain and condemnation were utilized this time, thus razing homes and history in nearly every town that would eventually become divided by and home to the Connecticut Turnpike (also known as the Connecticut Thruway and the Greenwich-Killingly Express), which was designated Interstate 95 in 1958.

Up on the serene parkway, the cats' eyes reflectors lining the curb glowed, and young girls took out their fathers' cars. One Fairfield woman recalled driving her father's Porche sixty years earlier: "I drove with my foot to the floor…and of course I never did have a driving lesson."[51] Drivers marveled at each unique bridge, looked down as they crossed eight rivers and appreciated the intricate "crossing of the railroad, the Norwalk River, and Route 7 in Winnipauk, a section of Norwalk."[52]

In the early months of 1940, construction crews toiled at the Stratford-Milford end of the Merritt in order to complete a new Housatonic River crossing. Constrained by funds, the highway department opted to lay a metal open-grid bridge, which created a feeling of insecurity and rumbling movement for sixty-five years until it was replaced by a new bridge with a concrete roadbed. However, the metal grid bridge did succeed in slowing down drivers, perhaps the most or only effective speeding deterrent on the Merritt. It could be said that since the road was so much fun to drive, it lured motorists into speeding—not a problem unique to the parkway, but it was endemic and enduring.

Decades into the future, one speeding story comes to mind. A young, well-off man, who had been jilted by his girlfriend, took his Ferrari heading east onto the parkway, ostensibly to elude his woes. It was the Testa Rosa 1964 Grand Prix pace car. He easily outran the first few police but was eventually stopped by a police-constructed roadblock after a long run but before crossing the Housatonic. When the trooper approached the stopped sports car, he calmly asked for and received the driver's license and then proceeded

THE STATE OF CONNECTICUT REQUESTS YOUR PRESENCE AT THE CEREMONY MARK-ING THE COMPLETION OF THE MERRITT PARKWAY AND THE OPENING OF THE FIRST SECTION OF THE WILBUR CROSS PARKWAY TO BE HELD ON LABOR DAY, SEPTEMBER 2, 1940, AT TEN O'CLOCK IN THE MORNING, DAYLIGHT TIME, AT THE CENTER OF THE NEW BRIDGE JOINING STRATFORD AND MILFORD.

The second opening saw politicians and Schuyler Merritt's daughter cutting the ribbon. The prominent local Boothe family attended. *Courtesy of Stratford Historical Society.*

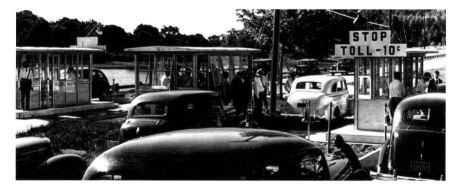

Interim tollbooths were erected in 1939 to collect tolls mandated by the governor. *Courtesy of Jill Smyth.*

to tear it into small pieces and scatter them on the ground, declaring, "You will never, ever, need this again."[53]

On September 2, 1940, in the last of the Merritt's "Opening Ceremonies," former governor Cross and Governor Baldwin together crossed the final

NOT ALLOWED
ON
PARKWAY

Trucks, Busses
Business Vehicles
Trailers
Animals, Bicycles
Pedestrians

←

SPEED
ON PAR
40

NO ADVERTISING
MATTER ALLOWED
WITHIN PARKWAY
RIGHT OF WAY

→

THE MERI

CONI

ALL-YEAR GAT

Welcome to our S
stay here and to co

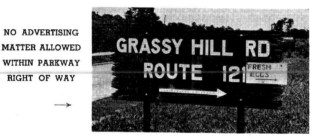

With weekend and summer motorists inundating the parkway, the state needed to educate and advise tourists. *Courtesy of Connecticut Department of Transportation.*

RRITT PARKWAY COMMISSION

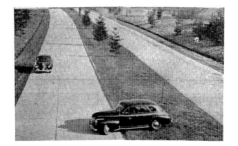

DON'T SPEED
IN EXCESS
OF
POSTED LIMIT

←

DON'T
MAKE
U-TURNS

←

PARKWAY

CUT'S

NEW ENGLAND

nt you to enjoy your

E. Baldwin
Governor

DON'T THROW
MATCHES
CIGARETTES
REFUSE
OR
PAPER

→

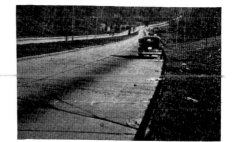

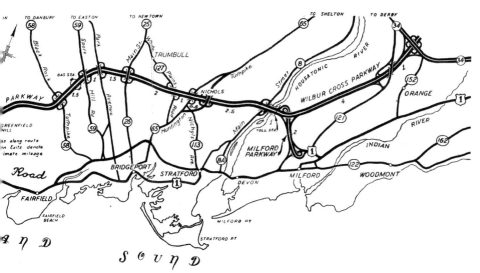

section of the thirty-seven and a half miles of the Merritt ending at the new bridge. Again dignitaries gathered, including the prominent Boothe family of Stratford (see Chapter 7 for more on the Boothes). This time, Merritt's daughter Louise Merritt Dalton cut the ceremonial ribbon. Merritt's other daughter, Katherine, a doctor, would remain involved with the parkway and its citizen action groups into the 1970s.

In 1941, the permanent rustic log cabin–style toll plaza was erected on the eastern bank of the Housatonic, mimicking similar structures being built in parks around the country. Vigorously opposed by Connecticut and Westchester residents, the governor pushed through ten-cent tolls to be collected for the extension of the parkway toward Yale and Hartford. That section of road would be named the Wilbur Cross Parkway, eventually sharing the same numerical designation, Route 15. Confusion about when, where and why the name of the road changes from the Merritt to the Wilbur Cross continues to this day. By the end of 1941, the Wilbur Cross Parkway reached Route 34, the Derby–New Haven road in Orange, taking commuters past the Yale Bowl, directly into New Haven and Yale. The journey from New York City to a Harvard-Yale football contest could now be driven in less than three hours.

From New York City, via the Hutchinson River Parkway, to the Merritt Parkway, one could drive "express" and in a landscaped setting as far as a local road toward Route 34 and Yale, or one could dip south toward Milford and the Post Road on the eastern side of the Housatonic River. The Milford Parkway, a two-mile connector, was also dedicated on September 2, 1940, and continued the look and feel of the parkway: divided and wooded with intimate access ramps when it was finished. It was also known as the Milford Bypass and dumped traffic heading in the direction of the shoreline towns, Rhode Island and the Cape back onto the Post Road heading east. And traffic could also head west back over the George Washington Bridge into Stratford and the thriving industrial city of Bridgeport. Eventually this Milford Parkway would also connect directly to the Connecticut Turnpike, which would be built very close to the old Post Road in Milford, eighteen years later.

The Merritt Parkway Commission (MPC) now took control of the parkway regulations, roadside development, speed limits, concessions and embellishments with enthusiasm. The commission spent years examining the location of every accident on the parkway and reviewed each curve. The final 1947 speed study concluded, among other things, that with higher speeds, certain access-egress (on-off) ramps would need to be reengineered

for higher speeds. Three shifts of state police patrolled the Merritt around the clock, yet motorists still had many "at fault" accidents on the road, mainly due to speeding.

To cater to the hordes of pleasure drivers coming from New York and points farther west, the highway department conjured up the idea and a drawing of a twenty-five-acre picnic area in Trumbull, complete with pool and brook, west of the New York–New Hampshire (NYNH) railroad branch. It never happened as residents protested "not in our town." Another picnic ground proposed by the Merritt Parkway Commission in Stamford at High Ridge was again defeated by the NIMBY (not in my backyard) attitude. A Merritt Parkway Museum was proposed to be opened in Stamford and was never built. A proposed roadside restaurant in Easton went all the way through the process for bids (it would've been a Howard Johnson's), but it was never built. Another proposed restaurant in Norwalk was not built. The FCPA had proposed a direct roadway in Westport, grade separated at the Post Road, from the Merritt to the Sherwood Island state park beach, which didn't happen. A Greenwich fishing pond open to tourists was proposed and dropped. Sometimes money and oftentimes local residents' opposition prevented these Merritt Parkway tourist add-ons. In 1945, famous tenor James Melton, chairman of the Merritt Parkway Commission, sought and received from the legislature $150,000 for construction of a museum on the Merritt Parkway to house historical exhibits and Melton's antique automobile collection. When the bill came up from the house to the senate for passage, Melton was present and, on being asked, sang "When Irish Eyes Are Smiling" to the assembly. The assemblymen cheered.[54] The museum, along with other proposed attractions and tourist facilities, was never built. It seems everywhere something was proposed along the parkway, opponents supported the noncommercial park-like settings.

Back on the Merritt, six service stations—three sets of dual-facing stations—were constructed in New Canaan, Fairfield and then Greenwich. These Colonial Revival structures were built during 1940 and 1941 to provide gas, picnic areas, restrooms, snacks and automobile supplies to the motoring public. The Merritt Parkway Commission came out with rules-of-the-road pamphlets to deter roadside picnicking, stopping on the roadway, littering and speeding. The commission also took up the issue of speeding and speed limits, sponsoring an in-depth traffic study of speeding and accident locations. It should be noted that the Merritt was statistically deemed to be a very safe and well-designed parkway, although there were some outspoken detractors.

By December 1941, the war had claimed everyone's attention. Plans for parkway embellishments and the romance of driving the Merritt took back seat to Pearl Harbor, news from the front and local war efforts.

THE WAR AND THE MERRITT

As men left for the armed services, women took over in the tollbooths, furbished with their own natty uniforms. The women, dressed in nifty olive-gray skirts, jackets and "kippy little caps," greeted the motoring public in both directions at the Greenwich and Stratford ends of the road. Because of the gas ban, the number of cars passing through the toll in a twenty-four-hour period had fallen from 50,000 to about 6,500 in 1943. The only time trucks were welcome on the parkway was during the war years, and smaller supply trucks that could fit under the bridges started rolling with war goods in June 1943. One exception to the truck ban was "authorized" wreckers out to help stranded motorists. Especially during the war, motorists were driving on poor, patched-up tires. When Bill Strain's father—owner of the Round Hill (Northwest Greenwich)

War supplies were moved on the Merritt Parkway starting in 1943. This imaginative drawing by Dunkelberger shows a convoy. *Courtesy of the Merritt Parkway Conservancy.*

To provide fuel, maps, automotive supplies, snacks and restrooms, six Colonial Revival buildings were built in 1940–41. *Courtesy of Weld Thayer Chase Collection, Connecticut State Library, RG 69:036.*

service station—left for war duty, Bill took over. "During the Second World War, though only 14, Bill patrolled the Merritt Parkway in the wrecker."[55] In June 1945, the lights of a navy truck went out, and the civilian employees of the navy got out to change the fuse, leaving the truck on the roadway during a foggy night. When a car hit it, four people were killed. The truck was loaded with torpedoes, which, amazingly, did not explode.[56] As soon as the war ended, trucks were again banned on the Merritt Parkway.

In Bridgeport, the enormous Boston Avenue 1915 building owned by General Electric was a busy munitions manufacturing plant. With its five floors, six-foot-thick brick walls and thirteen divided wings, it was symbolic of what was now important in Connecticut—defense contracting and the manufacture of war-related supplies. These defense businesses positively affected the Connecticut economy for another four decades.

Post War

The Merritt Parkway was part of the reason the United Nations considered putting its world headquarters in Greenwich starting in early 1946, introduced as a forty-two-square-mile campus just north of the Merritt,

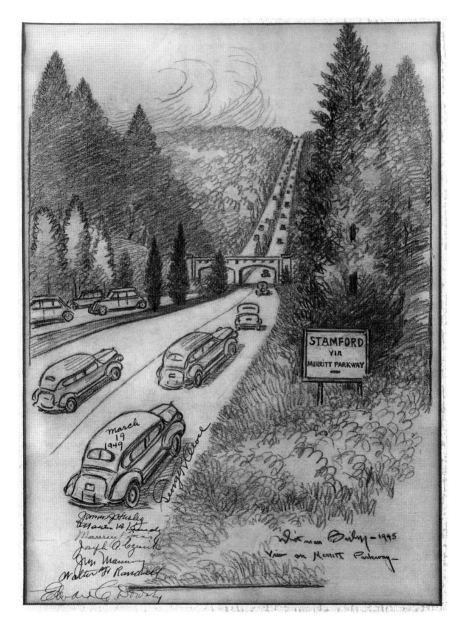

Bailey's drawings of local scenes appeared in the *Stamford Advocate* for thirty years; like many artists, he showcased the parkway. *Courtesy of the Wise family.*

including North Stamford and a part of Westchester County. Greenwich residents politely but firmly rallied against the "intrusion" of international traffic, foreign nationals, media and potentially the danger of a "target" in their neighborhood. Prescott Bush penned a letter in the local press detailing three reasons the United Nations Organization should look elsewhere.

Once the Post Road congestion and ugliness was improved, all of Fairfield County was blight free and highly desirable; property values rose all along the path of the Merritt Parkway. Fairfield County's population was rising at a rate significantly higher than the national norm, and so were real estate prices as prospective new residents looked for year-round, summer and weekend homes. According to Page Dougherty from the *New York Times*, "For New Yorkers who wanted to escape the miasma of the city without leaving the region, Fairfield County was the ideal destination. In terms of mileage it was close; in terms of attitude it was 'stellar miles away.' Beyond much of a doubt, it was the opening of the parkway that helped precipitate the hegira to Fairfield County."[57]

Dougherty captures the essence of the 1940s after the war. The exodus from the cities was on. Veterans were returning home and needed housing. Over the next two decades, the population of Connecticut's largest cities would shrink while suburbs would become the homes of the majority of Connecticut Yankees, as happened all across the nation. Urban workers could easily commute by car or rail back to their ideal home, and New Yorkers were exiting the city via the Merritt, for a visit or for good. This was a decade that began to reshape the region from farms and country estates to suburbia and, eventually, into the first megalopolis.

A SIDE NOTE

Artists and the Parkway over the Years

Within a decade of opening, images of the Merritt Parkway appeared in artwork: from songs to photography, paintings and drawings and from movies to the written word. The Merritt Parkway inspired legions of artists. In Stamford, Whitman Bailey drew local scenes. Bailey, a nationally recognized artist was colorblind; he worked for the *Stamford Advocate* for thirty years and helped found the Stamford Historical Society. Howard Heath, a WPA artist, painted a series of watercolors featuring the Merritt in the

CUTS FILLS

. 6, NO. 1 Published Monthly by and for the
Connecticut State Highway Department JANUARY,

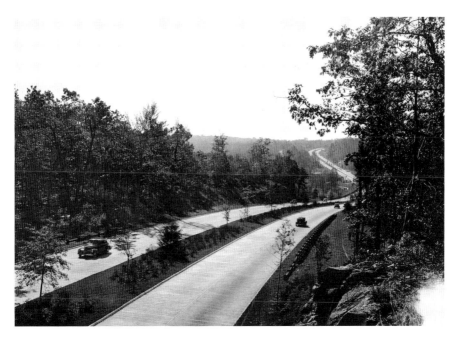

Opposite: Images of the landscape art and architecture of the Merritt appeared on everything from postcards to magazine covers (shown here) and advertisements. *Courtesy of Connecticut Department of Transportation.*

Above: As the landscape started to fill in, the long, framed views surprised and delighted motorists at every bend. *Courtesy of Weld Thayer Chase Collection, Connecticut State Library, RG 69:036.*

1930s. Poet Denise Levertov waxed eloquent about the Merritt Parkway in her poem "Merritt Parkway," as did American poet Robert Bly in "Sleet Storm on the Merritt Parkway" in 1962. Famed artist Willem de Koonig painted *Merritt Parkway*, a prized oil on canvas, in 1959. He said of it: "I like New York City…but I love to go out in a car…I'm just crazy about going over the roads and highways…When I was working on the Merritt Parkway picture, this thing came to me; it's just like the Merritt Parkway."

John Lennon was said to have driven the Merritt Parkway for song inspiration. Photographers have flocked to the Merritt for decades; some, like Connecticut tintype photographer Nate Gibbons, have been photographing the Merritt bridges for decades. Comedian David Letterman made the Merritt a national source of humor as he chronicled his speeding adventures and run-ins with troopers on the parkway. John Russell, *New York Times* writer and author, wrote eloquently of the Merritt. In the 1948 movie of the

novel by the same name *Mr. Blanding Builds a Dream House*, Cary Grant and Myrna Loy are seen driving to their dream country home on the Merritt. Gregory Peck's wife, Jennifer Jones, is picked up on the parkway by police in *The Man in the Gray Flannel Suit*. Also filmed on the Merritt in 1995 was *Die Hard: With a Vengeance*, starring Bruce Willis. Two films and two public TV shows have been made about the Merritt. Lisa Seidenberg in 2008 filmed the documentary *The Road Taken…The Merritt Parkway*, and in 2010, Eliza McNitt directed and Charlie Greene produced the short fantasy *The Magic Motorway*. The Merritt has been referenced in endless magazines and books about roads and about Connecticut, starting with Norman Bel Geddes's 1940 book, *Magic Motorways*. The Merritt Parkway is featured in the 2004 *Life* publication *America's Most Scenic Drives*.

4

THE 1950s

Emergence of the Suburbs

Car of the Decade: Ford Thunderbird "T-bird"
On the Car Radio: "All the Way" by Frank Sinatra

The 1950s were a transitional decade for the Merritt Parkway. It was the decade that began to change the original design and character of the parkway. As a result of the continual growth of Fairfield County, engineering "improvements" were ordered. The migration from New York to the suburbs continued to rise. Fairfield County was not only an attractive bedroom community for New York City but also becoming an attractive site for businesses to build corporate campuses. By 1959, Columbia Broadcasting had moved into Stamford, and in Wilton, Perkin Elmer and Escambia Chemical Corporation had built offices. The traditional manufacturing cities of Bridgeport, Stamford and Norwalk were trying to attract new industry. Other towns were shying away from industrial development, as was the case in Greenwich when the Norden Division of United Aircraft Corporation proposed to build a new plant.

Fairfield County had become a favored destination for exurbanites, offering a "cultured" community to reside in and raise children. The Merritt and the commuter train line to New York City made this possible, bringing economic prosperity and development to the communities. With this prosperity came the misfortune of traffic congestion. The Merritt's popularity for weekend drives and daily commutes pushed the volume of traffic from 6,430,097 cars in 1941 to 9,703,447 in 1951. Injuries and fatalities on the Merritt became the focus of concern for the Merritt Parkway Commission, state police, the

highway department and Connecticut legislators. Engineering design defects, drivers exceeding the posted speed limit and increased traffic volumes were cited as contributing factors. The Merritt Parkway Commission provided the citizens' perspectives and advocated for the Merritt Parkway throughout the 1950s.

In 1951, a legislative conference to study parkway traffic was held in Hartford. Members of the state traffic commission, the highway department commissioner, the state police commissioner and the state motor vehicle commissioner discussed recommendations to improve safety on the parkway. Highway department commissioner G. Albert Hill and motor vehicle commissioner Kelley were in agreement that an additional highway was needed in Fairfield County as "the Merritt parkway is not adequate to handle the present heavy flow of traffic." The perennial problems of reckless out-of-state drivers and speeding were cited as contributing to accidents. It was noted that speed limits are "set by experts employed by the State Traffic commission" with the exception of the Merritt Parkway, where the Merritt Parkway Commission regulated speed limits.[58]

The following month, the legislature held another hearing on parkway safety with thirty people attending, including Theodore Watson, chairman of the Merritt Parkway Commission. Mr. Watson explained that the majority of traffic violations were caused by out-of-state drivers, drivers passing on the right and speeding. He recommended hiring additional patrolmen to augment the current forty parkway patrolmen. Commissioner Hill also appealed for additional construction funding without success as the topic of how to raise the revenue was debated without resolution.[59]

While the legislature studied the parkway problems, the state police were exceedingly frustrated with drivers exceeding the 55-mile-per-hour speed limit, with occasional speeds of 90 to 120 miles per hour. Motorists violating traffic laws were so numerous on holiday weekends that elevated traffic towers on the parkway were set up during the Labor Day weekend in 1951 to serve as bond-posting stations.

New methods for controlling speed on the parkway were introduced using "psychological, mechanical and selective" techniques. Marked black and white cars were introduced as part of a safety experiment to determine the psychological effects of the driver becoming more "safety conscious." The first enforcement campaign of the decade was launched with the state police commissioner announcing, "An arrest will be made for any moving violation" on the parkway. It was successful as the accident rate dropped 30 percent in a three-month period. During the same enforcement campaign,

the "escort system," better described as moving roadblocks, tested the patience of drivers. Two police cars would drive side by side at the speed limit. This was effective, as cars were forced to drive the speed limit, but impractical to implement.[60]

The election of Governor Abraham Ribicoff in 1955 brought tougher enforcement of traffic laws to reduce accidents and fatalities on Connecticut roads. The *New York Times* wrote that "he understood the importance of traffic safety long before most other officials in the nation realized that in rapidly urbanizing states near large metropolitan areas, traffic would soon reach lethal volume and speed."[61] At the end of the decade, he dissolved the Merritt Parkway Commission, as well as several other commissions.

In 1957, Governor Ribicoff ordered the Highway Safety Coordinating Committee to study the engineering, safety and enforcement on the Merritt Parkway and to make recommendations on improvements to reduce accidents. Members of the committee included representatives from the state safety commission, motor vehicles, state highway department and state police—not the Merritt Parkway Commission. This was the first time since the 1920s that the people's voice was silenced.

Four recommendations were made to Governor Ribicoff. First, road signage should be in conformance with national signage, as detailed in the *Manual on Uniform Traffic Control Devices*. Second, strict enforcement of traffic laws should continue. Third, development of an anti-hitchhiking public relations campaign targeted for servicemen and college students was suggested. Finally, further study of the parkway to correct "inadequacies" contributing to accidents should be undertaken.[62]

In 1957, the highway department announced sixty-two trees would be cut down in the median to reduce accidents resulting from cars crossing the median into oncoming traffic or striking the interspersed trees. The trees would be removed in seven locations, the most accident-prone sites, and steel rail barriers would be installed. The announcement was met with public anger and disagreement between the Merritt Parkway Commission and the highway department on jurisdictional control of the Merritt. In June, the commission gave approval to remove trees in the median. However, in an October 14 letter from the Merritt Parkway chairman Watson to the highway department commissioner Newman Argraves, the commission rescinded its June approval as "it was discovered at the September 5th Commission meeting that several of the continuing Commissioners were under the impression you were asking to cut down 7 trees and not 62 trees at 7 locations."[63] Therefore, no trees could be removed without further approval

from the commission. In the same letter, Chairman Watson reiterated the jurisdictional responsibilities of the commission as interpreted by outside counsel hired by the commission in 1949. Commissioner Argraves wasted little time in outlining what his understanding of the responsibilities of the commission was and those of the highway department. Commissioner Argraves offered to meet with Chairman Watson and the state's attorney general to clarify the jurisdictional duties.

In late October, the press reported that Commissioner Argraves was moving ahead with his decision to remove the trees, prompting the commission to threaten to file an injunction against the highway department to stop the removals. Commissioner Argraves agreed to not remove any trees until the commission met on November 7 and had time to review the highway department's report on installing the steel barriers.

The 1957 *Merritt Parkway Median Barrier Study* examined the use of median plantings and steel rail barriers in the median. Mass plantings of multiflora rose bushes were suggested as previous safety studies found they were effective in safely stopping vehicles traveling at higher rates of speed. The disadvantages of plantings included maintenance, the fear that passengers wouldn't be able to easily exit their cars after an accident, the concern that the height of the plants would preclude police officers from observing traffic on the other side of the median and the fact that it would take approximately six years for the plants to grow to the desired width and height to be effective in stopping cars in the median.

The report determined the steel guiderails were more effective in preventing head-on collisions when cars jumped the medians. The report noted that the number of accidents may increase because of cars being deflected back onto the roadway (instead of resting in the median), but the number of tree strikes and cars landing in oncoming lanes would decrease.

At the November meeting, a compromise was reached to remove only thirty-six of what turned out to be eighty-two trees marked for removal. Safety engineers determined that forty-six trees could be saved because the trees were far enough from the center of the median, where the railing was being installed, or the trees could be protected on both sides with the railing. The railing was installed in seven areas among the towns of Greenwich, Stamford, New Canaan, Norwalk and Trumbull.

Design Changes

The first significant design change on the parkway occurred in 1955 with the elimination of "Deadman's Curve" in Greenwich. Highway commissioner Hill cited this half-mile portion on the parkway as the only "major engineering defect on the Parkway." The westbound traffic lanes moved 120 feet to the northwest in this half-mile segment, and the grade was raised to improve the sightlines. In 1957, at the Stratford gateway (exit 53), a new interchange was designed to relieve traffic congestion generated from the Sikorsky plant and commuters from the Housatonic River Valley area.

Other incremental safety projects included extending the length of the deceleration lane and ramp at Black Rock Turnpike and extending one of the Route 7 ramps. Safety pushed further modifications—the ramps and shoulders in Greenwich were widened, the wooden guiderails were replaced with two-strand cable barriers, concrete bumpers approaching bridge abutments were installed and rest turnouts were cut into the right of way for drivers to pull over.

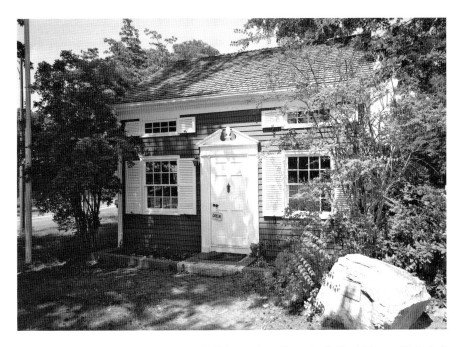

In Greenwich, this colonial saltbox was built by students from the Bullard-Havens Technical High School in Bridgeport and J.M. Wright Technical High School in Stamford. *Courtesy of Library of Congress, HAER CONN, 1-GREWI,14—1.*

An enhancement to assist drivers at night was promoted by Dr. John Door, a resident of Westport. His wife had difficulty maneuvering the parkway at night, most likely because the mirrored cats' eyes were no longer prominent, so he advocated for striping the outer road edges in reflective paint. A test patch was painted with positive results; subsequently, the entire length of the parkway was painted, as well as the Wilbur Cross. The Hutchinson Parkway received the same striping, resulting in a 50 percent reduction in accidents.[64] Even though the Merritt Parkway Commission was locked in a power struggle with the highway department, a single citizen's thoughtful suggestion significantly improved the parkway.

LITTERING

Littering on the parkway was an unending problem throughout the decade. In 1951, the Merritt Parkway Commission hosted a meeting at the University Club in New York to ask corporations to include a message in their advertisements asking people to please keep trash in their cars instead of throwing it out the windows. Representatives from Ford and General Motors, Philip Morris, Garden Club of America, Hershey Company and various paper product companies attended. According to Chairman Watson, "I was surprised at the enthusiasm which was shown at the dinner. The people who make the litter were most enthusiastic and one of them stated that it was the finest movement they had heard of in years…The Ford Company representative stated that he would suggest to the company that they install a receptacle in their cars to contain litter."[65] Many of the companies subsequently included an anti-litter message in their advertisements.

By 1957, crews in each of the five maintenance zones on the parkway were devoting each Monday, April through November, to picking up litter. The average cost for litter removal was $11,767.00 annually, or $314.15 per mile. Chairman Watson thought it was a good time to host another dinner in New York with corporate representatives and Governor Ribicoff. Before responding to Chairman Watson, Governor Ribicoff asked Commissioner Argraves's opinion on hosting a dinner. The commissioner responded in a letter that said the highway department had signage that littering was unlawful and fines would be imposed. Additionally, there were trash receptacles on the parkway. He concluded in the letter, "The traveling public is fully cognizant of our efforts to discourage the scattering of litter, and the majority make

an effort to conform. Personally, we believe that any such conference and dinner as described [by] Mr. Watson would be unnecessary."[66]

The dinner meeting moved forward and was held in July 1958 with thirty corporations in attendance as well as Governor Ribicoff. The companies pledged to join in an advertising campaign to end littering. Chairman Watson also suggested passing out litterbags at the service areas and having each town devote a day to picking up litter.

1955 Floods

The floods of 1955 were two of Connecticut's worst natural disasters. The August and October floods impacted sixty-seven towns, leaving 103 persons dead, 1,100 homeless and 86,000 unemployed. In August, Connecticut experienced back-to-back hurricanes within one week, dropping twenty inches of rain, and the resulting floods ravaged towns along the Naugatuck, Farmington and Quinebaug Rivers. October gale-force winds and heavy

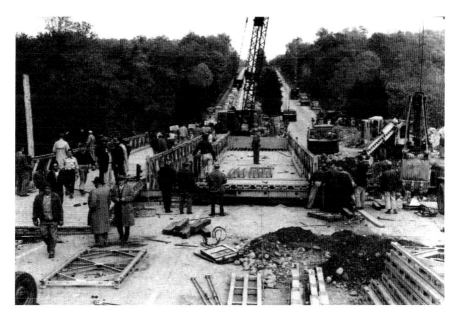

Hundreds of men worked around the clock building two Bailey bridges to replace the washed out bridge over the Silvermine River after the flood. *Courtesy of Larry Larned Collection.*

rains brought flooding to the shoreline towns, including Norwalk.[67] The bridge spanning the Silvermine River was destroyed, and the Merritt closed in Norwalk with traffic detoured to local roads and the Post Road. Two Bailey bridges were constructed in two days for westbound traffic. Instead of waiting for additional Bailey bridges to arrive from Ohio, the eastbound lanes were constructed from timber beams affixed to steel supports. The temporary bridges were used until a bypass road was constructed to carry traffic around the bridges. The new steel-and-concrete bridge opened in 1956.

MERRITT PARKWAY RESTAURANT

In 1957, a bill was introduced in the legislature authorizing the highway commission to construct and maintain a restaurant. The bill passed even though local restaurants and businesses were against the idea, as it would take customers away from their establishments. The site of the proposed Howard Johnson's Restaurant was on the northbound traffic side of the parkway near the Easton Turnpike in Fairfield. The state was acquiring 16.8 acres of the 18.0 needed through condemnation. The owners of the land took the case to the state Supreme Court to stop the action on the grounds that "a restaurant operated by a private concern for profit is not public use as normally required by eminent domain."[68] And it was never built!

CONNECTICUT TURNPIKE

Citizen advocacy to protect the landscape was not solely focused on the Merritt Parkway, as properties were being condemned and razed to build the Greenwich-Killingly Expressway. Many towns were bisected, neighborhoods destroyed and the landscape and sensitive ecosystems erased. Lofty goals of easing traffic on the Post Road and the Merritt Parkway and revitalizing local economies were promised. The promises were realized in the '60s when, as more people relocated to Fairfield County, employment rose in areas adjacent to the turnpike. Ironically, twenty years after opening, the turnpike fell victim to the same congestion problems experienced by the Post Road and the Merritt Parkway with highway experts again looking for a solution.

The Commission Is Dissolved

With the 1958 reelection of Governor Ribicoff, the Merritt Parkway Commission was doomed. "Economy and efficiency" were cited as the reasons even though the commission's members were volunteers and its annual expenditures were less than $500 per year. The Connecticut Highway Department would assume the duties of the commission. Chairman Watson expressed his doubts of whether the highway department could effectively manage the parkway with the same oversight and care as the commission. Would the Merritt be treated like any other route in the state instead of a parkway? In a short note to the governor, after the commission was abolished, he wrote:

> *As the Merritt Parkway Commission was originally formed to protect the interests of residents of Fairfield County and to keep the Parkway as a parkway, I am wondering, now that the Commission has been abolished, whether it would not serve the purpose to appoint a small committee of Fairfield County residents as an advisory committee to be available to the Highway Department if some special problems arise.*[69]

As we now know, it would be a very long time before the Merritt would have citizen representation within the highway department again. However, within a decade, citizens' voices of concern for the Merritt and against excessive road expansion united in many towns through various organizations to supplant the official role of the citizens' commission, which lasted for twenty-eight years.

The 1960s

From Pleasant Motoring to Commuting—Parkway Changes

Car of the Decade: VW Bug (or van) with stickers
On the Car Radio: "Little Deuce Coupe" by the Beach Boys and "Mustang
Sally" by Wilson Pickett

The '60s was a decade of upheaval. The Beatles were yet to land in New York and rock the *Ed Sullivan Show*. The explosion of drug use and the escalation of the Vietnam War had not yet occurred. Protests against war and draft, polluters and police were still simmering; on the federal front, important environmental, historic preservation and resource sensitive transportation acts were in the making. These would all impact the Merritt Parkway within a decade or so.

Suburbanization had been in full swing for at least thirty years in Connecticut. Instead of FCPA's predicted population of 636,000 (by 1980), the population of Fairfield County had already exceeded that number by 1960, when it reached 653,589. The suburbs, lauded in cultural staples such as *The Dick van Dyke Show* and *Leave It to Beaver* on the ubiquitous new television sets, were in full growth. In the '60s, the population of these bedroom communities near New York City would grow another 21 percent.

In a *Connecticut Humanities News Council* essay, Western Connecticut State history professor Herbert Janick defines the suburban pattern by these characteristics: low density of residential settlement and a separation of home from work. He identifies suburban values, including glorification of home ownership, living close to nature, primacy of the nuclear family and hostility toward the city.[70] Along the New Haven–New York train

The 1960s saw the Merritt Parkway change from a road driven for pleasure and sightseeing to a busy commuter artery, as per this postcard. *Courtesy of Jill Smyth.*

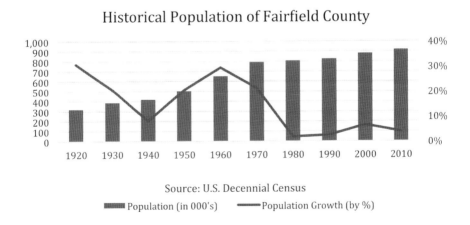

Historical Population of Fairfield County

Source: U.S. Decennial Census

Population (in 000's) Population Growth (by %)

FCPA projections did not anticipate the high percentage of actual growth as illustrated. The explosive growth peaked in Fairfield County in 1960. *Courtesy of Laurie Heiss.*

line and along the Merritt, bedroom communities for affluent urban commuters grew faster than the norm. Families of more modest means needed to commute farther, creating what A.C. Spectorsky termed "the exurbs" in 1955.

What the members of the state highway bureau did not realize while at their drawing tables was that after 1965, the majority of Connecticut jobs were no longer located in a city core; the corporate headquarter exodus from New York City to Fairfield County was beginning (with GTE and General Electric leading the way), and "ultimately industry and commerce followed their workers and customers to the suburban fringe."[71] The previously acceptable methodology of determining where Connecticut's nearly one million cars would need to go and on what roads, coupled with the help of federal funds for road construction, supported the "concrete" mentality that predominated the transportation strategy and plans of the '60s.

Connecticut's road-building professionals (and their construction industry suppliers) worked in the fourth-oldest highway department in the nation, still glowing in praise for its Merritt Parkway vision, and they knew no bounds. Highway commissioners stayed in their jobs; there were two commissioners between 1938 and 1955 while the governor changed eight times during the same period. One might wonder who controlled the road builders. In theory, it was the Transportation Committee of the General Assembly, often managed by representatives of the most rural communities (before 1965 and reapportionment, an archaic system of legislative representation permitted a tiny minority of rural voters to rule the General Assembly). But in reality, no one controlled the highway department, the road builders, except perhaps the governor. Transportation jargon, so-called standards and the indiscriminate citing of "for safety reasons" could, and did, make gubernatorial management of the highway department difficult.

By 1950, Connecticut had one of the most extensive road systems in the country at some three thousand miles of paved highway in a state that covers only five thousand square miles. During this period, the engineers planned expansion for dozens of roads, but the need for additional capacity and the pattern of travel (known in highway department parlance as origin and destination data) was changing. It was the citizens, even more than the politicians, who realized these flaws of overbuilding as the grand road-building plans of the '60s unfolded, especially those that affected the beloved Merritt Parkway. It became the lightning rod for tension between the taxpaying users and the federally funded road builders. The landscape

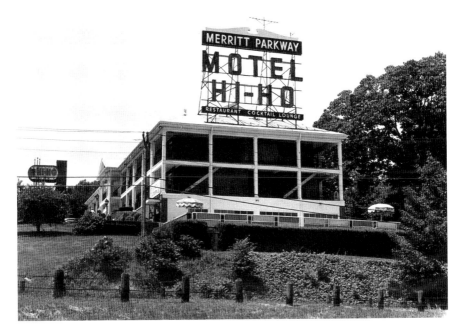

The Hi-Ho has been welcoming weary travelers on the Merritt for over five decades. *Courtesy of the Fairfield Museum and History Center.*

filled in and began to need attention. But the leafy, green, intimate tunnel for which it would become known was in place—an accident of nature, adored by commuting fans. Maintenance issues grew along the parkway as budgets, expertise and funds were reduced. Bridges needed repairs. By the '60s, many of the artisans, laborers, construction workers and highway department employees involved in the creation of this ribbon of road through a park had started to retire. Commuters who spent every workday on the Merritt took notice. The '60s saw the only motel—the first commercial intrusion—open on the Merritt.

The burgeoning suburbanite families of Fairfield County had two cars, and with the rising cost of real estate in the shoreline towns, people headed north of the eleven towns bordering the Merritt. In these more northern twelve Fairfield County towns, the "new frontier," the Merritt made commuting to suburban, corporate park jobs possible. Well before the explosive growth of Stamford's white-collar jobs and corporate headquarters in the '70s, the highway department had started road designs for the key northbound routes intersecting the Merritt, proposing "realignments," massive interchanges and a northbound Super Highway (aka Super 7), all affecting the Merritt.

In a largely nontransparent decision process, the highway department continued to design road expansions as traffic increased on the Merritt and on the newly opened Connecticut Turnpike. Fairfield County, and all counties in Connecticut, was dismantled as a governing body in 1960 because Governor Ribicoff felt strongly about reducing government waste. For years, the county government functions had been limited and were widely viewed as inefficient, although it was the Fairfield County group and FCPA that had led the parkway movement and the county that had been the bonding agent. As a county, the focus was often on the Merritt, which had become the poster child of the now defunct county groups, but remained the mascot of Fairfield County thereafter. Most of the county positions and tasks were transferred to the state, and various regional "planning organizations" arose in the absence of county structure. The Merritt Parkway Commission was abolished in 1959, but still the Merritt Parkway (the only road in Connecticut so overseen) remained excluded from the sole authority of the highway department. This process of the highway department seeking legislative approval for Merritt Parkway projects was a holdover from a legislative act in the '40s. Although the Merritt Parkway Commission was not given "teeth" when it asked for them in the '40s, this remnant of legislative authority still required the highway department to go to the legislature for *any* changes on the Merritt Parkway, though it was the only road with such restrictions. On any other road project, the highway department needed no authorization to build whatever it determined was needed. The General Assembly's approvals for safety studies and engineering studies do not in and of themselves sound harmful but, in fact, seem rather prudent. After 1959, and without the Merritt Parkway Commission watching the highway department or the parkway, vast design changes that were being engineered for the Merritt without citizen input had been approved and later were presented at confusing public hearings in something of a fait accompli—or so the engineers thought.

Resistance on several fronts started occurring in the late '60s and continued for decades. Residents protested every road expansion from the Merritt/Turnpike heading north, to and from the next frontier of suburbia and commerce. And where these north–south corridors intersected the Merritt, the highway department engineers had blithely added to the interchange work the massive widening, straightening and roadbed moving plans. Had the department designed these interfaces with thoughtful aesthetics, wooden guiderails, massive plantings and a concern for beauty and scale, resistance would likely have been different.

The Fairfield County projects involved three north–south roads that were becoming congested, partly since the Merritt carried new traffic to those connections. Suburban sprawl and scatter combined with desired economic growth and unscientific traffic projections resulted in these significant road projects. It was the theory of the day that if roads were expanded, then the economy around the larger road, and particularly at interchanges, would grow due to greater access, more cars equaling more development and more economic growth. Cities and towns that were somewhat industrial in nature or indiscriminately business friendly tended to support this purported road-building benefit while more suburban towns began to view this additional concrete-based growth as detrimental. The possibility that the local residents might not want a new and larger road was a foreign concept for the state highway department. It was used to being welcomed by the affected communities—such conflicts were managed without sensitivity to community relations. The highway department merged with other state departments into the Department of Transportation (DOT) at the end of the '60s.

Planning had started for improvements in existing Route 7 in 1955, and funding for a project doubling the lanes was approved by the General Assembly in 1957, although these improvements only occurred in spots. By 1961, a $130 million project for a newly located Route 7 Expressway (Super 7) was announced with public presentations beginning in Norwalk in 1961 and ending in Wilton, Ridgefield, Redding and Danbury by 1965. Norwalk in the south and Danbury in the north generally supported this superhighway as a means of getting workers back and forth between towns, and they wanted growth—or at least, this is what those mayors claimed. Super 7 was to continue on to the ski trails of Massachusetts and Vermont, substituting car travel for an old train line that had carried skiers north until the 1960s. The project had supporters who bought into the DOT mantra of economic improvement, but it also had many vocal detractors. A massive multi-stack interchange between Super 7 and the Merritt was originally planned, realigning and widening the road and taking out four bridges and tunneling six lanes under the Merritt.

The rural, bucolic, wooded, wetland-laden towns in between Norwalk and Danbury were surprised at DOT plans that were discovered in town planning processes or Connecticut Highway Department hearings. Started in 1968 in Redding, the

Citizens Action Council formed to give all the town's citizens an option, a choice between ugly, unbridled urbanization, or a planned, orderly, imaginative pattern of growth. The first inkling of what the road would mean came at a Planning Commission meeting in the fall of '67…the commission's consultant, TPA of New Haven, unveiled a map which showed a big, black line running east and west from a proposed Route Seven interchange on Redding's western border…it chewed through much of the most scenic and historic areas. "My God, it's going right through my house," said one resident who just happened by the planning meeting that night.[72]

A CAC director told members at a 1968 meeting about a successful campaign to eliminate two interchanges along the Merritt Parkway when it was built: "This was not an accident. It was because people demanded that there be no interchanges at those points." Redding invited highway department planner Lembit Vahur to a town meeting where the proposal was denounced in speeches and voted down 335–3. In neighboring Ridgefield, the town voted 188–1 to oppose the interchange. In a letter to Governor John Dempsey, CAC officials asked "whether Mr. Vahur is expressing your views and the views of your administration, when he says that the State Highway Department puts in million-dollar interchanges where it pleases without regard to the wishes of the people in the locality?"[73]

In Ridgefield and Wilton, concerned citizen action groups decided Route 7 was altogether unnecessary and environmentally damaging to sensitive wetlands and water supplies and altogether too noisy, too large and out of scale with these green, rural exurbs. Officials and residents were apprehensive and, after researching the proposals, often alarmed in the towns of Ridgefield, Redding and Wilton. In the same year, the Committee to Stop Route 7 was formed and included residents of all the affected towns.

Additionally, in 1967, the Assembly mandated Commissioner Howard Ives to make a study on interchanges in Fairfield and Trumbull per Special Act 333 and, in the 1969 Public Act 755, funded $800,000 for engineering. A $4.7 million appropriation was sought in 1969.[74] However, in a 1973 letter from the Save the Merritt Association (SMA) to Governor Thomas Meskill, SMA states, "We believe the legislators in 1969 merely funded the planning and engineering studies called for in 1967, and DOT is utilizing a blanket authorization in Section 8 of PA 755 to design and construct a major highway project." Any changes to the Merritt, and only the Merritt of all Connecticut state roads, still required approval of the General Assembly.

Individuals in Fairfield, Trumbull, Monroe and Shelton would first see these plans in December 1972. The Save the Merritt Association was formed in the spring of 1973.

Numerous and varied opposition groups formed over a five-year period as public meetings were held in the late '60s and into the '70s. In the Route 25 corridor, terminating in Bridgeport, many claimed the Route 25 expansion would relieve significant congestion to and from the north and their slogan was "Route 25 by '65!" while another group called the plans unworkable and formed into a group called the Committee to Stop the Road to Nowhere. Just east of Route 25, Citizens for a Sensible 8 decried the massiveness of the proposals involving Routes 8 and 25 running north–south only a couple miles apart and then joining together, destroying the Merritt bridges and requiring massive takings of land, including homes, alongside the Merritt to support the interchange design.

Clearly, the citizens of Bridgeport, Trumbull and Fairfield (and Newtown, Monroe and Shelton) were not all in agreement as to the need and benefits of these projects, but when it was discovered later that designed into the complexity of these plans was a parkway roadbed realignment (expansion), opposition grew exponentially. On the other hand, the industrial city of Bridgeport favored all road expansions that would bring workers and possibly growth into the fading Park City.

The state highway department, which had celebrated its aesthetically outstanding masterpiece of a road only twenty years prior, designed multilayer intersections with out-of-proportion ramps and proposed the destruction of two delightful bridges passing over and under the Merritt in Trumbull. Where had the ecologically sound, context-sensitive road designers and master landscapers of the early '30s gone? What were these raised superstructures doing in the viewshed alongside the Merritt? As recalled by the volunteers of the Stratford Historical Society, the doomed Huntington-Nichols Turnpike Bridge was where the ice cream truck had always parked: "It used to be delightful," they said. Road builders were empowered by the federal focus on highways, the priority funding for roads and the dedication to the interstate system with the Federal Aid Highway Act of 1956. However, many residents of Fairfield County were incubating a new concept in which less was more—and perhaps bigger really wasn't better. They started to think of the Merritt's concrete bridges as a state treasure, as monuments worth saving.

On the parkway, commuters were still enamored of the green tunnel and, during traffic delays, could study the bridges. But the roadbeds on the

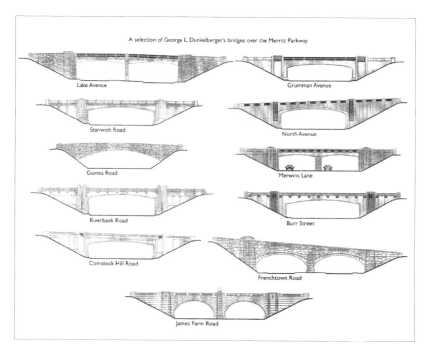

A selection of George L. Dunkelberger's bridges over the Merritt Parkway

Lake Avenue

Grumman Avenue

Stanwich Road

North Avenue

Guinea Road

Merwins Lane

Riverbank Road

Burr Street

Comstock Hill Road

Frenchtown Road

James Farm Road

The unmaintained trees, shrubs and vines have grown over the road and cover the bridges (originals drawn here) that cross the parkway. *Courtesy of the Merritt Parkway Conservancy, drawn by Nigel Holmes.*

Trees filled in the canopy, enclosing the road, and the understory trees suffered. *Courtesy of the Merritt Parkway Conservancy and Catherine Lynn.*

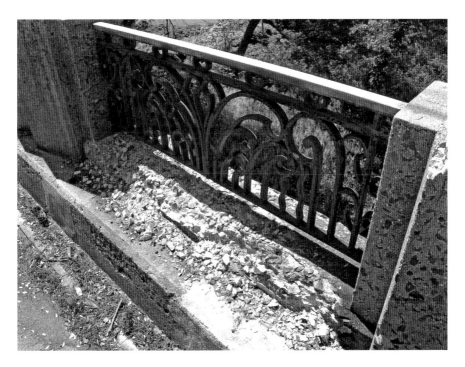

Concrete began to deteriorate on parapets, bridge façades and underneath the bridge. *Courtesy of Jill Smyth.*

acceleration and deceleration lanes were pitted, guiderails were damaged and vegetation was climbing up to cover the decorated wing walls (side supports of the bridges). And worse, the tolls had increased for motorists, and "they pay four times as much in tolls as the state pays to maintain and occasionally improve the parkway," claimed a 1963 *Bridgeport Herald* series by Harold Flincker titled "Queen of Expressways Wears Shabby Garb: Outmoded, Hazardous." He does claim that "the Merritt Parkway remains one of the nation's most beautiful roads" at least.

The state troopers and what was, as of 1969, known as Connecticut DOT took safety seriously on the Merritt, even going so far as handing out free coffee to New Year's Eve travelers on the big night ending 1966. Since the Merritt opened, accidents and fatalities were tracked by officials and in the media, and all too often, it was the same causes: excessive speed, alcohol, falling asleep and, in the '40s, car failures like flat tires. Some things never change.

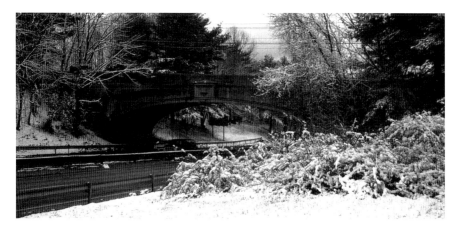

Here the parkway is in its winter blanket. Each season brings a new look to the Merritt.
Courtesy of Bruce Radde, The Merritt Parkway, *copyright 1993 by Yale University Press.*

6

THE 1970s

Citizen Action Arises and Mostly Prevails

Car of the Decade: Ford Gran Torino
On the Car Radio: "American Pie" by Don McLean

Eternal vigilance is the price of a beautiful Merritt Parkway.
The 1970s was the decade when environmentalism was born. The first Earth Day was observed in 1969 and began a movement. The Clean Air Act was amended to regulate mobile sources of pollution. The energy crisis, particularly in the form of gas shortages, affected everyone. The Merritt Parkway played out these national trends on a local scale.

The National Environmental Policy Act passed, retroactively effective January 1, 1969. The Committee to Stop Route 7, a small group of determined and environmentally aware residents, filed a suit this same year for an injunction, claiming that the Connecticut DOT had not filed accurate environmental impact statements (EIS) for each project segment. Because federally funded road projects require these statements, a court injunction was issued by federal judge Jon O. Newman in July 1972, stopping one of the largest and longest-planned Connecticut road projects in its tracks. In Norwalk between 1969 and 1971, a 1.2-mile section (four lanes each way) had been completed, but the rest was halted by the injunction. Diane Haavind, vice-chairman of and the day-to-day face and voice for the Committee to Stop Route 7, summed it up: "I was gratified but not surprised in 1972 when the law was upheld and the injunction issued. I was educated in journalism and fine arts. When we moved to Wilton in 1968, I wanted to paint the area's landscape. Rather than paint the landscape, I would try to save it."

Bob Morgan, the chairman of the Committee to Stop Route 7, remains ever wary of Super 7 construction. "It was an interesting, educational, and challenging experience fighting the State of Connecticut over Super 7."[75] By 1975, the Regional Plan Association (the same RPA of the Plan for NYC and Environs in 1929) weighed in, calling for the continuation of the initial section of lower Super 7 only another 1.5 miles up to the Merritt but not beyond. In a *Wilton Bulletin* article, "Super 7: A Real Threat Then, Unfathomable Today," it was noted that "Super 7 has been called a white elephant that would despoil the countryside by opponents in all three states" and also insisted "that the proposed three-level interchange with the parkway which opponents of the plan have said would rival the Bruckner Boulevard interchange in the Bronx in size, be redesigned so as to affect the parkway's rustic beauty as little as possible."[76] The RPA did support the completion of Routes 8 and 25, still halted in 1975, "but urged that interchanges also be redesigned to leave as much of the parkway intact as possible."[77]

Meanwhile, ten miles east of Norwalk, in December 1972, the DOT presented a baffling reconstruction design for the Merritt Parkway to constituents gathered in a Fairfield school. The road realignment from Fairfield through Bridgeport and ending in Trumbull was a nearly six-mile segment where the DOT proposed a new road alignment for the Merritt "since they were bringing in new ramps to connect the expanded Routes 8 and 25." It was wide enough for eight lanes and narrowed back to half that width at Burr Street. Even citizens untrained in engineering could see that bottlenecks would form at the connecting points, which could necessitate widening the rest as soon as the project was completed.[78] DOT officials promised they would only lay paving for two of the four possible lanes in this project. The residents of Fairfield and Trumbull did not believe them; or if they did, they knew the next project, almost certainly to widen the parkway, would be unstoppable. In the worrisome and confusing weeks after the presentation, there were numerous sightings of surveyors near the parkway by residents. Activist and Fairfield University professor Lisa Newton later recalled a conversation she had with Representative Elinor Wilber. Said Wilber, "There is too much secretiveness about this whole thing—even people with connections to the Governor's office can't find out exactly where the project stands now." Wilber worried that the money to go ahead with the project might turn up as soon as the legislature adjourned for the summer. And in another call with Representative Harry Wenz, Newton found he had written Commissioner Wood, ironically the same leader who oversaw the roadside development of the Merritt, to suggest returning it to the drawing board.[79]

"It is a great satisfaction that the 'proposal to ruin the wonderful road' has 'stirred a furor among Merritt Parkway enthusiasts in affected Fairfield County towns.'"

Katherine K. Merritt, M.D. (Daughter of Schuyler Merritt, after whom the Merritt Parkway was named.

Is this New York, Chicago, Los Angeles? NO...this is proposed for TRUMBULL, CONN.

Save the Merritt Association had the support of more than two thousand residents with individual chapters in Norwalk, Easton, New Canaan, Westport, Stamford and Greenwich and a home base in Fairfield. *Courtesy of Bridgeport Public Library History Center, Bridgeport, Connecticut.*

The Save the Merritt Association (SMA) was formed in 1973, under the leadership of Dave Rosow, Dr. Lisa Newton and others. Many letters flew between disparate Fairfield citizens and the DOT, attempting to get clarification about just what realignment meant until it became clear: they needed to draw a line in the sand and stop the potential widening of the Merritt whether it was happening in the imminent project or not. And a *New York Times* editorial in 1973 concurred with the SMA:

> *It is bad enough—though not surprising—that the engineers have rejected pleas…that the new interchanges and other safety features be redesigned to preserve the unique sylvan beauty and sensitive scale of what is surely one of the nation's most pleasant parkways. It is incredible however that they* [CT State Transportation Department] *should have the audacity to*

propose $32.5 million to slash trees and spread concrete for another ugly speedway when everything points toward lower speeds and less traffic on state and national highways.[80]

By July 1973, hundreds of citizens had come to understand that "realignment of the roadbed" meant a new widened footprint for future expansion. Elevated stacked ramps, demolition and widened replacements, straightening and supersizing were all a part of the proposal to expand Routes 8 and 25 and reconnect them with the Merritt. Not for the first or last time, the excessiveness of and need for the project were assailed in a November letter, excerpted in the following, from SMA to Commissioner Earl Woods's replacement, Commissioner Joseph Burns:

> *The convenience provided by constructing both interchanges is a flagrant waste of taxpayers' money. Approximately 7 minutes would be lost by a driver who would not have access to the parkway via route 8 and who would have to backtrack from 8 to 25 to the parkway. The added design and construction work to route 25 to allow complete directional changes would be minimal in comparison to the cost of building the route 8 interchange… we should not forget that the people of our state and the Judicial Branch have delayed construction of route 7.*

The DOT found its projects stopped in one section of the county, vigorously opposed in another part of the county and supported and cajoled toward immediate action in Bridgeport, and still officials weren't yet fully aware of the concurrent movement in Northwest Greenwich to get the Merritt Parkway listed on the National Register of Historic Places (NRHP) for a higher level of protection against the department that built the road. Looking back at this decade, you can see that thousands of citizens played a role in shaping the future of the Merritt.

The Save the Merritt Association held its first general membership meeting in July 1973 and had superb organizational skills—a mission, bylaws, funding, communication strategies and outreach efforts to other towns were in place within months. Independent subchapters of Save the Merritt in other towns also wrote letters and spoke at meetings up and down the parkway. In 1973, the sitting governor was Tom Meskill (Republican), and unlike the years up to 1955, the DOT/highway department commissioner churn was now keeping pace with the turnover of governors. Governor Meskill and Commissioner Burns were immediately inundated with letters about the 8/25/Merritt

Interchange project and undoubtedly were aware of the legal injunction against the Route 7/Merritt interchange project. Project opponents were courteous but insistent: there would be no "realignment"! In an early letter to Governor Meskill from the SMA, the SMA chairman quoted neighboring governor Nelson Rockefeller in discontinuing the Rye-Oyster Bay Bridge: "In this period of change…people are beginning to question whether all growth is automatically good—beginning to look at the quality of life… It is clear that the people want to look at decisions which affect the face of their land. They want to question carefully any development which brings massive changes."

It did not take long for Meskill and Burns to give in to pressure from letters, from the SMA, from politicians and from media coverage. On December 7, 1973, Governor Meskill announced in a press release that "he has denied the State Department of Transportation to go to bid on proposed interchange modifications to the Merritt Parkway…the Governor said Transportation Commissioner Burns has agreed to return the Routes 7, 8, and 25 interchange projects to design stage for further study." The inclusion of the Route 7 project was especially good news because the DOT had just won the appeal regarding the environmental impact statement and could have moved forward. In the press release, the governor mentioned that Commissioner Burns agreed with him that the beauty and charm of the Merritt Parkway must be preserved, which contrasted with Burns's November letter to the SMA, in which he said, "To conclude, in the judgment of the Department, the present design is superior to that which would leave the Parkway intact and should be pursued." It is a reasonable guess that the SMA sent this response on to the governor's office.

Coverage in the *New York Times* and TV news segments filmed on the Merritt abounded. The relief and thrill of the many activists spilled into the press. However, in Bridgeport, where Mayor Panuzio went on a retaliatory campaign in the media protesting that "down-county people have forced a decision on the Governor…which adversely affects the economy of this area in the name of aesthetics."[81] He met with the governor six weeks after the press release to demand that the redesign be speeded up. Apparently the governor agreed that a DOT-reported two-year delay in design was too long. In the same article in which Panuzio attacks the governor, SMA spokesman Dave Rosow expresses extreme gratitude to the governor for his important decision in December: "You chose to listen to the majority of Fairfield County residents who use the parkway and who saw the piecemeal destruction of it as an incredible

waste." With Bridgeport pushing for better connectivity to the north and beginning to suffer from crime, manufacturing loss and overall decline, the widening of Routes 8 and 25 was feverishly pushed as if it was a part of the salvation for this once prosperous industrial city. The DOT bounced back in one year with new plans for Routes 8 and 25 without the intrusive changes of the entire six-mile stretch of parkway. The project limits were scaled back and interchanges were redesigned, but those new designs still ended in the 1979 demolition of the Nichols-Shelton Bridge and the Huntington Turnpike Bridge, which were replaced with seven modern and out-of-character functional spans and overhead ramp configurations. It is interesting to note that after these roads to and from Bridgeport were completed, Bridgeport still declined significantly—by all measures—in the 1980s.

The Save the Merritt campaign was not finished. It had three persisting requests: 1) the Merritt Parkway Commission should be reinstituted ("if they had been in existence this conflict would have been addressed during design"),[82] 2) the Merritt Parkway should receive a Historic Landmark Designation either from state or federal authorities to protect it and 3) Save the Merritt representatives wanted to provide input to any revised plans. In 1976, Commissioner James Shugrue invited a less official, and less empowered, group of thirteen citizens from eight different towns to become the interim Merritt Parkway Advisory Committee (MPAC), providing an advisory role on Merritt Parkway issues until the passage of a bill re-creating the commission. When the General Assembly approved the 1977 bill re-forming the Merritt Parkway Commission, it went to Governor Ella Grasso (Democrat) for signature into law. On July 7, Governor Grasso vetoed this bill, citing its inconsistency with the Filer Committee Report and the Act Concerning the Reorganization of the Executive Branch of the State Government, which called for a reduction in autonomous state agencies. She did encourage the Merritt Parkway Advisory Committee to continue, which was something of a sounding board for the commissioner and his agenda. Save the Merritt supporters and possibly Commissioner Shugrue were unhappily surprised. Then, the governor went out on the parkway and ceremonially planted some dogwoods with a Connecticut agriculture team that was going to study which species would best survive salt and road conditions. Around the same time in 1978, Frank D'Addario, an MPAC member, donated about fifty dogwoods and nearly one thousand small pine trees to be planted on the parkway.

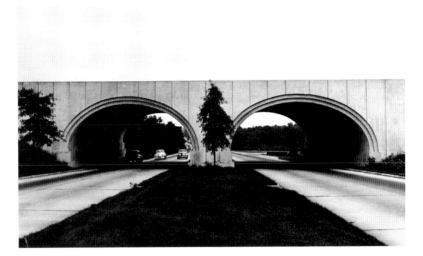

The double-barrel Nichols Shelton Bridge and the Huntington Turnpike Bridge, with its grapevine cast-iron ornamentation, were demolished in 1979. The ornament was reattached to a new modern underpass. *Courtesy of Library of Congress, HAER CONN,GREWI2—100.*

ONE FIFTH THE SIZE OF THE EMPIRE STATE BUILDING IS ABOUT TO MOVE INTO YOUR NEIGHBORHOOD.

Save Fairfield took out ads in local newspapers to help defeat this out-of-scale development on the Merritt. *Courtesy of Save Fairfield Committee.*

Back in Wilton, the successor organization to the Committee to Stop Route 7 was incorporated with remaining members and others into Citizens for Balanced Environment and Transportation (CBET). The DOT had appealed the injunction, circulated a revised draft EIS and redesigned the multilayer Bruckner Boulevard–type structure at the interchange. Existing Route 7 changes (known as spot improvement plans) were also designed in selected areas. The CBET members were organized and active, as was a corollary coalition of citizens from Norwalk to Danbury calling themselves Citizens for a Sensible 7 (CS7). There was also a group called COMET, Commuters for Environmental Transportation, which promoted mass transit alternatives and, in particular, improvements to the ConRail Danbury spur line that glides right under the Merritt. There was a decided theme connecting all these actions happening on, above and at the connections with the Merritt: a growing and genuine popular concern with the quality of the air, waterways, fragile wetlands, flora and fauna of the fast-disappearing open space that defined these fringe suburbs. Additionally, the residents worried about sound pollution, impervious surface coverage ratios and well water impacts. Eventually, dozens of professors, research colleagues and PhDs, organized by Yale-affiliated lepidopterist Victor DeMasi, would come to the Route 7 corridor to study the flora and fauna and created, over time, the monumental environmental treatise "New Route 7 Expressway Natural History Inventory 1991." Rare and endangered species that they found were researched, catalogued and recorded. The corridor of the right of way was an undisturbed greenway and a treasure-trove of life, particularly around the wetlands. Previous EIS studies had identified none of these species.

The Northwest Association of Greenwich, a Save the Merritt affiliate but also an active association in its own right, had started and resourced an application to the state historic commission in 1974, detailing the qualifications of the Merritt Parkway for eligibility for listing on the National Trust for Historic Preservation (NTHP) that was approved by the director of the state historic commission, also known as the state historic preservation officer (SHPO). From there, the application went to the department of the interior, where the U.S. Interior secretary administers the process by which a resource is listed on the National Register. However, in November 1974, Ella Grasso was elected, and she brought in the shortest-serving DOT commissioner in the state's history of highway leaders, Samuel Kannell, who resigned after nine months. Commissioner Kannell immediately, vocally and unequivocally opposed the Merritt's being listed on the National Register as he felt maintenance and construction would be hampered by this designation. In support of Kannell,

Governor Grasso, in November 1975, asked that the nomination of the Merritt Parkway be withdrawn. In her letter to Secretary Thomas Kleppe, the governor cited the beauty of the highway and assured him that DOT respected the parkway's heritage, but she noted that many transportation improvement programs were under construction and others were pending to provide improved connections with the north–south expressways. It was safe for the growing legions of Merritt preservationists to read between the lines: there was more change to come, and she was not on their bandwagon. Both hard-won activist initiatives—landmarking and an empowered commission— were shot down by her within two years.

By the mid-'70s, there had to be some DOT staff just dedicated to keeping track of the citizen opposition groups and keeping up with those communications and meetings. Granted, the projects being opposed were not all on the Merritt, but they all affected the Merritt and would alter it in meaningful ways. Sometimes the changes in the Merritt happened bit by bit, and sometimes the proposed changes were dramatic. It was hard for any one group to follow the incremental changes. However, Citizens for a Balanced Environment and Transportation, Inc. (Redding, Ridgefield, Wilton and some of Norwalk), reached across the Merrit, so to speak, in a March 15, 1974 letter to Fairfield residents. One could guess CBET had access to the SMA membership or a larger Fairfield list. The letter from CBET president Haavind resulted in CBET and SMA working together:

> *Dear Fairfield Citizen…Because of recent concern regarding reconstruction of the Merritt Parkway, we are writing to you to bring your attention to a related situation that is also a basic factor on the fate of the Merritt: the intentions of the Connecticut Department of Transportation to build north– south freeways through southwest Connecticut to feed into the Merritt. Our particular interest at this time is the proposed new Route 7 for which a mammoth interchange with the Merritt is now receiving attention…In short, it appears that we will be forced to continue our court battles to see that realistic environmental studies are conducted. So far the fight against Route 7 has received no support from the Save the Merritt Association although the fate of the Merritt is much dependent on whether or not the proposed Route 7 feeds into the Merritt…Right now the parallel rail line in the Route 7–Danbury corridor is being recommended for abandonment under the Rail Reorganization Act of 1973…we need your help, and I hope it is plain that those who wish to "Save the Merritt" need ours.*[83]

Listed on the CBET letterhead are its many directors and honorary trustees, Lewis Mumford and Stewart L. Udall. Haavind goes on to ask for letters to officials, for letters to the DOT and for financial support, noting they had already raised $20,000 for attorney fees. She states, "Many more thousands in dollars will doubtless be needed…to stop the road builders from their relentless pouring of concrete." Haavind, unknowingly, was almost paraphrasing Congressman Stuart McKinney, who had written in his support of the SMA, read at its 1973 membership meeting, "In my view, the indiscriminate pouring of more concrete is not one of the answers for the 1970's."

In 1975, when new designs came out for Routes 8 and 25, the May 30 *Bridgeport Post* reported, "Citizens and Trumbull officials last night expressed near unanimous opposition to the state's plans. Said Trumbull First Selectman James Butler, 'We are not satisfied and should have something different.'"

ENERGY CRISIS AND ENVIRONMENTAL LAW

The energy crisis lingering throughout the decade, which caused gas shortages and rising gas prices, did affect the pace of automobile traffic growth on the parkway and probably the speeding, as motorists conserved fuel. DOT was charged with finding and providing alternatives to driving. Commuter lots were built, and rideshare programs were implemented. DOT created significant busing options during the '70s, and towns did the same. Commuters turned to the trains when possible. As the Penn Central Railroad folded, the MTA and the Connecticut Department of Transportation rescued the commuter rail line (ConRail) and promised new rail cars and maintenance. Regionally along the Post Road, additional busing options were created.

On the environmental front, hydrocarbon emissions were reduced starting with many 1963 models, and hydrocarbon and carbon monoxide emissions from tailpipes were cut by about two-thirds on 1968 models. These were reduced another 30 percent on 1970 models. So by the mid-'70s, those older cars were being replaced, and the theory was that "by 1975, we should have reduced auto emissions by about 85% and beyond that date we should do even better."[84]

THE PEOPLE SHAPED THE ROAD

On balance, the citizens of Fairfield County had done well in this decade by reverting to the notion that democracy prevails and that determined citizens (or citizens with attorneys) can stop the huge bureaucracy that is any state department of transportation. In the end, the citizens had more wins than losses. Super 7 and its mega-interchange were being reviewed, and while Routes 8 and 25 proceeded, demolishing two delightful and historic monumental bridges and adding seven run-of-the-mill steel span underpasses and literally miles of ramps running in every direction, the parkway's roadbed was not altered. Access ramps were unstacked and scaled down. The fight about future expansion was won, for the moment. Today, the expanded six lanes of 25 North come to a two-lane Route 25 just before Monroe, and as you drive the expanded portion with few other motorists, one has to wonder what problem they were solving, what forecasted congestion they were addressing. As for the thwarted effort to list the parkway on the National Register of Historic Places, it continued. This nomination effort

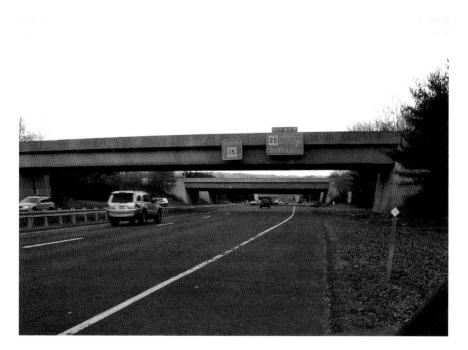

Interchanges and underpasses for Routes 8 and 25 changed the Merritt in Trumbull. *Courtesy of Jill Smyth.*

would follow a fascinating path for a dozen more years, involving hundreds of citizens, historians, preservationists and politicians along the way.

Governor Ella Grasso resigned, due to cancer, after six years, and Lieutenant Governor William O'Neill filled the unexpired term and was elected to two more terms, serving as governor the entirety of the '80s.

The decade went out with a bang—that of the two historic Merritt Parkway bridges hitting the ground to make way for expanded Routes 8 and 25. However, in 1978, the retracted Merritt Parkway nomination had nevertheless resulted in the Merritt's becoming eligible for full listing on the National Register. Therefore, unbeknown to most, it was now afforded the protections of the National Historic Preservation and the Department of Transportation Acts of 1966.

THE 1980S

Interchanges and Proposed Changes on the Merritt

Car of the Decade: Ford Escort
On the Car Radio: "Little Red Corvette" by Prince

Almost fifty years after the planning of the Merritt as an alternative to the crowded Post Road, the Merritt in the '80s would itself be considered for widening to alleviate the overcrowding on I-95. The landlocked and gridlocked roadways of Fairfield County had started to impinge on the economy of Connecticut. Bordered by excessively expensive property and having nominal right of ways, the road expansion suggestions for increasing the capacity of the major highways, including the Merritt, became nearly absurd, derailing politicians who grasped for a solution to an overpopulated area that depended on automobiles, not mass transit. The love affair with the car had ended.

Adding to the widespread complaining about congestion and the roadways were the toll increases, although the truck lobby on 95 was the loudest complainer. Toll collections were blamed for backups. Bills to eliminate tolls were introduced and then defeated by the state senate. Tokens started being used and collected on both the Merritt and I-95 in 1982, and it was soon discovered that these toll tokens would also work in New York City subway turnstiles. Although immediately asked by New York City and state officials to change the tokens, Governor O'Neill quickly refused to stop the use of these tokens. Then, ten people were arrested in New York City, inadvertently using the tokens. Among them were Greenwich residents. Less than a month later, the State of Connecticut agreed to alter its tokens.

On Route 7 and the Norwalk Portion
Near the Merritt

In the Merritt/Route 7 Interchange and Route 7 standoff, citizens were alert to the fact that the 1972 injunction was vacated in 1980, and they appealed. Citizens for Balanced Transportation, Inc., succeeded the Committee to Stop Route 7 in the *Committee to Stop Route 7 v. Volpe* case. Environmental impact statements were improved during the '70s. Therefore, citizen action groups responded with requests for a supplemental EIS. The original EIS was over twenty years old and unreflective of current findings, which included significant rare species, an Indian burial ground, endangered aquifers and significant wetlands. The DOT finished designs for the next section, up to and impacting the Merritt. But money was in short supply. The citizen groups Citizens for a Sensible 7 (CS7), CBET and COMET focused on promoting the much less expensive alternatives to Super 7 (expanding existing Route 7 where needed) and attended all public meetings for the project. In September 1986, at an Army Corps of Engineers public hearing, the wetlands affected by construction and the required permits were discussed. As a result of the review and input from citizens, the corps responded by temporarily withholding the DOT permit in 1986. In October, 200 Redding and Ridgefield residents met to express support for an alternative to Route 7. Redding first selectman Maryanne Guitar called for a meeting with DOT representatives that occurred in November, with 350 residents in attendance: "DOT representatives were unable to allay the concerns expressed by the audience, or to give satisfactory answers to the questions raised. COMET held an informational public hearing with approximately 300 residents and in a non binding Ridgefield poll sponsored by the First Selectman, the proposed Super 7 highway was defeated 3 to 1."[85]

These public meetings and legal actions taken by CBET caused the Department of Environmental Protection to hold hearings in 1987 at which the expert witnesses like Bruce Campbell Associates testified that by using "DOT's own data," it was determined that the traffic projections for the proposed new expressway were defective and highly inflated by the incorrect use of census data.

Meanwhile, the corps' temporary withholding of the DOT permit to continue pushing the Super 7 Connector toward the Merritt was still in place. In May 1987, the U.S. Army Corps of Engineers sent the DOT a cease-and-desist order to halt the 2.5-mile extension of the existing

1.2 miles of Super 7. "Several wetlands—marshy or swampy areas—are located along the rights-of-ways, officials said. Wetlands are protected by law, officials said, because they are a natural purification system for water."[86] Federal inspectors visited the site on May 1 and observed material discharged into the wetlands. DOT chief Art Grune disagreed that the material was within the regulated wetlands. "Residents who protested the construction at a demonstration Sunday evening said yesterday they were happy with the cease-and-desist order."

> *I'm very pleased said Wilton resident Pierre Cooley, a promotional art director for the New York Times Co. Cooley, who has installed an acre-sized Japanese garden on his property said he was opposed to the new superhighway, especially the destruction of trees along exits 39 and 40 on the Merritt Parkway. "Wonderful," said Meredyth Davidson, a Wilton landscape designer, who said she filed a formal complaint April 7 with the state Department of Environmental Protection. "There was some work in the wetlands," said Dennis Cunningham, assistant director of water resources at DEP. "My staff and I were somewhat outraged by the cavalier attitude on the part of the contractor. We have issued a directive to the department to cease work in certain wetlands. The wetlands areas should be restored."[87]*

By 1990, all of the elected officials were on board with the local road widening alternatives and were publicly against the Route 7 expressway. Elected officials of Ridgefield, Redding and Wilton appealed to other state and federal agencies, demanding a supplemental EIS. The professional flora and fauna study was completed and was indisputable—the original EIS was environmentally suspect.

AGAIN IN FAIRFIELD

Between 1985 and 1987, the town of Fairfield again took up a protest, ostensibly about a zoning exception that allowed a residential district to be rezoned as a Designed Research District for a project that didn't happen. Subsequently, the land was sold to a developer who wanted to build a 425,000-square-foot office park with all the accompanying cars, up to two thousand daily, next to the Merritt Parkway. However,

the campaign, called the Save Fairfield Committee, was really about retaining the character of the town and its northern section in particular, which includes Greenfield Hill, the notorious holdout community that defied the highway department and denied any exits from the Merritt, which residents felt would be an intrusion from the otherwise adored parkway. Said resident Barbara Bartlett in a letter to the first selectman, published in the local *Fairfield Citizen*, "Thousands of tourists come here every year to drive through the Greenfield Hill area during Dogwood Festival. They do not come here to see office developments…Must we always destroy our best places and cover all our natural beauty with concrete?" This letter was one of well over a hundred published letters, articles and editorials about the controversy.

Then state representative Christine Neidermeier, the ranking Democrat on the General Assembly's Transportation Committee, informed residents at a neighborhood meeting in February 1985 that the state traffic commission received an application from the developer for permission to alter the configuration of the Merritt Parkway interchange near the proposed office park. Further, due to the natural flow of increased traffic, Fairfield residents were convinced that the dreaded Exit 43 from the Merritt was again being contemplated to handle predicted new traffic volumes. It was a protracted battle that even featured a sign-waving protest, with singing, outside a meeting tent where the developers were speaking on their site. Said one participant, "Oh, what a lovely protest." Fortunately for the Fairfield protestors, the market softened for commercial developments. One of the owners of the property, F. Francis D'Addario, died tragically in a plane crash in 1986, and thereafter, new plans for a residential development were substituted for the large office park; it remains undeveloped today.

And in general parkway initiatives at the 1986 legislative session, the DOT was again mandated to study the safety of certain on/offramps. Largely, these safety projects extended the acceleration and deceleration lanes for safer merging and more deceleration time before a tight right curve down onto the crossroad. In some areas, the on and offramps were next to each other—not a problem at a thirty-mile-per-hour exit speed, but not well delineated for the unfamiliar motorist or for drivers exiting too fast.

MORE DEVELOPMENT

After building the High Ridge office park and GTE headquarters in the '60s, just after urban-renewal leveled nine square blocks in Stamford, the F.D. Rich Company went on to build the horizon-defining Landmark Building and, in the '80s, added 10 Stamford Forum, as well as 4, 6 and 8 Stamford Forums, to the new city center. The one-million-square-foot Stamford Town Center mall was also added in the '80s, making Stamford a significant retail center in addition to a significant center of employment. This city increased in population and jobs while Bridgeport had lost both. The traffic patterns in Fairfield County had also changed direction, with significant morning traffic congestion in the west/south direction on the Merritt (and 95) and the reverse occurring in the afternoon. It was no wonder that the DOT eyed the Merritt Parkway for a solution. At the same time, lanes were being widened where there was space along 95. What the transportation planners were thinking in the late '80s to solve Fairfield County's growing congestion and overdevelopment issues was hair raising.

The violence in New York City during the '80s was driving even more people to the suburbs and exurbs. Stamford had gone well beyond designed enterprises of the '60s and corporate office parks and research facilities of the '70s to become the employment capital of western Connecticut. In 1986, the General Assembly called for a corridor study of congestion and transportation remedies for the overcrowded Fairfield County roads (again). The department of transportation worked in the last few years of the '80s on the inflammatory *Southern Connecticut Transportation Corridor Study*, released in March 1990. The study described the D'Addario scenario, which would create a duplicated Merritt for eastbound traffic. The Northwest Greenwich Association's Joan Caldwell (also on MPAC) and Save the Merritt's Dave Rosow were both right all along: the parkway needed protection against those who had built it. Commissions and landmark status were great ideas to head off ruination. As for the actions of the Merritt Parkway Advisory Committee between 1978 and 1990, a quote from Catherine Lynn, former editor of *Connecticut Preservation News* is telling: "As the experience of the old Merritt Parkway Advisory Committee has suggested, citizen or expert committees that lack legal authority are ineffectual if the bureaucracy is unsympathetic."[88]

F. FRANCIS D'ADDARIO PLAYS AN ONGOING ROLE IN THE SAGA OF THE MERRITT PARKWAY

Who was this colorful millionaire? F. Francis D'Addario was a prolific businessman who lived in Trumbull and had business headquarters in Bridgeport. He had ventures in everything from real estate and hotels to broadcasting, casinos and a women's pro-softball team with an estimated net worth of $162 million.[89] His company had received the DOT contract to rebuild the intersection at GE's new headquarters at Exit 46 off the Merritt. He owned the Hi-Ho Merritt Parkway Motor Inn at Exits 44 and 45 in Fairfield. Oddly enough, records show that he was an active member of the Save the Merritt group in Fairfield in 1973. (Obviously they were open to all members, but looking back, it must have required above-average volunteer skills to manage that organization, communicate with DOT and attend endless meetings.) In 1976, Mr. D'Addario was asked to join the interim Merritt Parkway Advisory Committee, which became the commissioner's advisory group after the bill establishing the commission was not signed into law.

In December 1984, D'Addario started lobbying for his own vision of a wider Merritt Parkway that effectively created a second parkway alongside the first and replicated the bridges. He came up with his own price tag of $300 million, although attendees at his events were quoted as skeptical of his estimate and how Connecticut could raise that or any larger sum of money. Among other road presentations, in June 1985, he was soliciting project support from the members of the Fairfield-Westchester Chapter of the Association for Corporate Growth. "The project, which he said could be built in two or three years, includes the construction of a connecting highway in Stamford to link the Merritt with the Connecticut Turnpike… D'Addario said the additional highway would make the turnpike and parkway safer because it would alleviate the traffic and still leave a scenic road for lower Fairfield County residents."[90] In fact, as a single citizen in the construction industry and lobbying for more roadway business, D'Addario personally went town to town to promote the road widening. It was a rally against both the DOT and the D'Addario initiative that occupied the leaders of the Save the Merritt movement during the '80s. The various activist groups connected to form a united front against any significant alteration of the Merritt Parkway. "Since D'Addario, president of the company that has real estate and construction concerns, made his proposal to widen the Merritt Parkway, it had been under study by the State Department of Transportation. Gov. William O'Neill said, however, that he has no plans to widen the parkway. Stamford Mayor Thom Serrani…termed the idea 'pie-in-the-sky.'"[91]

Frank D'Addario presents his "duplication" of the Merritt as a solution to congestion at a business meeting in Stamford in 1985. *Courtesy of Hearst Conn Media Group, copyright 1985.*

The DOT and Commissioner Burns spent a lot of time trying to convince the public that they were not considering widening the Merritt while trucking lobbies and certain individuals were promoting the widening. In addition, also from Bridgeport, the senate chairman of the legislation's Transportation Committee said the state would have to expand the Merritt Parkway in Fairfield County to relieve chronic traffic congestion in Southwest Connecticut. "The pressure to expand the Merritt Parkway is going to be overwhelming," said Senator Howard T. Owens, a Democrat and Transportation Committee co-chairman. "Merritt Parkway expansion is really the only way to go when you look at the cost."[92] The leaders of the legislative committee were divided on the issue. Key lawmakers believed it would be prohibitively expensive and impractical to turn the parkway into a major expressway. "I don't perceive the Merritt Parkway ever being used as an expressway. The Parkway was designed as a scenic route for cars and there would be a great resistance to expansion of that road," said Representative Moira K. Lyons, a Democrat from Stamford and Transportation Committee co-chairman. "I don't know how this state is going to seriously talk about turning the Merritt Parkway into a Superhighway because of the cost," said Representative Elinor F.

Wilbeer from Fairfield, ranking house Republican on the Transportation Committee. "The cost is staggering. You'd have to talk billions."[93]

TOLLBOOTHS DISAPPEAR

It was all the embellishments that made the Merritt unique. While no one enjoyed stopping to pay a thirty-five-cent toll on the Merritt, the rustic Adirondack-style tollbooths were part of the experience. However, in 1983, there was a horrific accident on I-95 in Stratford at the tollbooths, killing seven. As a congestion improvement measure and due to the accident and the fact that the road bonds were nearly retired, the General Assembly voted to abolish all tolls in the state, including those at each end of the parkway. Tolls stopped being collected in October 1985, and the booths were removed. No one thought there would be overall dismay at tollbooth removal, but such was the case. After much lobbying by Merritt enthusiasts, one set of tollbooths was sent to the Henry Ford Museum in Dearborn, Michigan, and one set of tollbooths was moved in large pieces off the roadway and over to Boothe Park (named for the same Stratford family) in Stratford, where they can be visited today. Along with the tollbooths, the small Boothe Park museum has the old toll collector uniforms tucked away.

According to Professor Chester Liebs, a road historian, the tollbooths are as important to the parkway as the tower is to the Empire State Building. "Once you start removing those features, you begin to lose all those qualities," he said. "It's a very powerful landscape corridor, with a whole sequence of visual events—passing under those bridges, stopping and going through the toll gate. You come out of the busy city and are in the gateway to New England. The tollbooths are part of that experience. They should not be taken away. They are a public treasure."[94] In a related event, René Anselmo of Greenwich offered a $1 million trust fund for preservation and restoration efforts on the Merritt, but he withdrew his offer after DOT refused his condition that removal of the old tollbooths be delayed.

By 1988, as the tollbooths were disassembled and hauled away, the media was starting a nostalgic look back at fifty years of the Merritt Parkway. Apparently, this road in a park was now old enough and still special enough that it was worth saving. Clearly, it was one of the grand public works of the Depression era and, per author Bruce Radde, one of the largest Art Deco collections in the nation. Mr. Radde was a history professor and an

Although preservationists protested, the tollbooths were removed, thus speeding motorists east to the Wilbur Cross Parkway and south onto the Milford Parkway and 95. *Courtesy of the Stratford Historical Society.*

After forty years of service, tollbooths get a free ride to nearby Boothe Memorial Park. *Courtesy of the Stratford Historical Society.*

architectural historian who started working on a book written about the parkway in the '80s.

OFFICIAL GROUP SPEAKS OUT TO SAVE THE MERRITT

The Connecticut Trust for Historic Preservation (CTHP) took the initiative to restart the nomination process for the Merritt Parkway's listing on the National Register of Historic Preservation. CTHP was created by special act of the legislature in 1975 to protect the cultural and architectural heritage of the state. Up to this point, there had been almost a dozen citizen action groups speaking out against alteration of the Merritt Parkway, directly and indirectly. But the Connecticut Trust had not previously been part of the headlines while trying to save the Merritt. However, their leadership and timing was good; it was important to stand up for a resource soon to be listed on the National Register. In 1990, they took a professional and vocal stance against the recommendations being considered for expansion in the corridor study. The thoughtful leaders within the CTHP summed up the essence of the problem: "The aggressive role of road building in leading development is ignored. A passive stance is assumed." Commissioners and DOT employees prioritized "the critical economic and transportation function of the parkway." Overall, the attitude of the road-building powers that be seemed to be "what development interests want, we'll build."[95]

By the end of the 1980s, DOT seemed to interpret their role as one of transportation and economic growth planners. They had a lot of federal funds for transportation infrastructure but no actual mandate to drive growth patterns in Connecticut.

8

THE 1990S

Expansion and Super Highway Stopped and Parkway Joins the National Register

Car of the Decade: Jeep Cherokee SUV, Dodge MiniVan or Ford F-Series Truck On the Car Radio: "Under the Bridge" by the Red Hot Chili Peppers

Cablevision and the Internet were in their infancy when the 1990s opened. The twenty-four-hour news cycle was covering the dismantling of the Berlin Wall and later covering the Oklahoma City bombing, LA riots, the Gulf War and the O.J. Simpson trial. The Internet grew exponentially, and so did the technology industry, ushering in an era of great wealth and prosperity. Fairfield County had the third-largest number of multinational corporations in the United States.

In 1990, the parkway celebrated its fiftieth anniversary. Unfortunately, once again, the Merritt's future was in limbo. The DOT had a new plan labeled "The Highway Concepts for Route 15," as set forth in the March 1990 *Southern Connecticut Transportation Corridor Study: Transit Strategies and Highway Concepts*. In August, for the first time in four years, the DOT called a meeting of the Merritt Parkway Advisory Committee to present details of the plan. Richard Martinez, chief of planning for the DOT, outlined the scenarios for widening the parkway.

Four plans were presented. The first plan added one lane of traffic to both the east- and westbound lanes. This plan would necessitate removing existing bridges with center piers. The second plan again added one lane of traffic to both the east- and westbound lanes. However, the median was narrowed to allow all six lanes of traffic to flow under newly constructed

bridges. The third plan would increase the parkway from four lanes to eight lanes. Construction of four new lanes would be built in the southern right of way. The original bridges would be saved with new, mirrored bridges constructed for eastbound traffic. Finally, the fourth plan did not add any additional lanes but made safety improvements to the parkway. The extra right of way had been purchased to allow for expansion of the Merritt but would eliminate the *park* from the parkway to which drivers and residents had become attached. So this option was considered unviable.

Mr. Martinez highlighted different design layouts incorporating confusingly all four alternatives with the parkway as described in the press:

> *From New York to North Street in Greenwich no lanes would be added, but some curves on the road would be straightened. From North Street the road would be expanded to six lanes to Route 104 in Stamford, where it would widen to eight lanes to Route 8 in Bridgeport. From there to the exit before the tunnel in New Haven, the road would be expanded to six lanes. The Den Road exit in Stamford would be eliminated under this plan.*[96]

The plans were based on projections that the number of cars on the parkway would double by 2010 without any mass transit improvements. If mass transit improvements were made, adding rail cars and bus routes and expanding commuter parking lots, the amount of traffic would increase by 80 percent by 2010.[97] (Recall the outside experts who refuted DOT's traffic predictions in the 1989 Super 7 testimony.) Effects of telecommuting were not predicted.

Early on in the efforts to stop the widening, the Connecticut Trust for Historic Preservation understood the destruction of the Merritt was more than a transportation issue:

> *The Trust is increasingly concerned about the deterioration of the cultural landscape as our region undergoes a dramatic population shift away from large urban centers toward small, semi-rural communities. Development pressures resulting from this shift all too often result in a homogeneous landscape of sprawl. This trend, which affects the quality of life in scores of Connecticut towns, is a primary concern of preservationists.*[98]

Strategies were also being studied by various regional planning associations with the goal to integrate transportation policies with land-use, housing and economic development policies to reduce reliance on automobiles. George

Harvey, chairman of the tri-state Regional Plan Association's committee and president of Pitney Bowes, Inc., wrote in an editorial, "We all need to look beyond the battle over expansion of the Merritt. The war is about reducing the demand for automobile use. Unless Connecticut adopts a more rational pattern of land use, it is a war that traffic congestion and pollution will eventually win."[99]

During the same time period the expansion plans were being promoted, the Connecticut Trust for Historic Preservation received a grant from René Anselmo, chairman of Pan American Satellite Corporation, to prepare the National Register of Historic Places nomination for the Merritt Parkway. The nomination was prepared by Catherine Lynn and Christopher Wigren of the Connecticut Trust for Historic Preservation. In October 1990, the state historic preservation board gave them an "approval for study," a go-ahead to prepare a nomination based on the resources seeming to meet the criteria for listing. Three members of the DOT attended the meeting to voice objections to the nomination. DOT commissioner J. William Burns wrote a letter earlier in September to the historical commission with his objections:

> The public that uses the Merritt Parkway deserves safety protection and it is my obligation as Commissioner of Transportation to provide it. From time to time, I will have to deal with those human values, while weighing the aesthetics and historic nature of the Merritt Parkway. Formal listing of the Merritt Parkway on the National Register will not provide any additional protection than it enjoys under present laws and regulations. This formal designation would only give the public the false sense that improvements to the Merritt Parkway would be prohibited. It is my opinion that this will hamstring me and compromise my duty to provide necessary and timely safety and capacity improvements to the Merritt.[100]

In February 1991, the state historic preservation board met again to vote on the nomination being forwarded to the keeper of the National Register of Historic Places. The meeting was attended by a large group of supporters and the press. Also in attendance were representatives from the DOT, representing the new commissioner Emil Frankel. The same objections were raised by the DOT—that the nomination would impede future safety improvements. However, this was not the case as the Merritt Parkway was "eligible for listing" on the National Register from the earlier 1970s nomination. This meant any federally funded work on the Merritt was subject to the federal regulations as if it were officially listed. In addition, the

Connecticut Environmental Protection Act afforded additional protections of allowing citizens to file suit to prevent unreasonable destruction.

The board approved the nomination for the Merritt's listing. Prior to the close of the meeting, DOT representatives delivered a letter from Commissioner Frankel stating his opposition to the listing. On April 17, 1991, the Merritt was listed on the National Register of Historic Places.

Commissioner Emil Frankel's opposition to the nomination was due to his recent appointment. He wanted time to study the impact the nomination would have on the DOT's management of the parkway. Commissioner Frankel, appointed by Governor Weicker, did not have any previous experience with the DOT and had many projects and challenges facing him when he was appointed. Mr. Frankel attended Wesleyan University and Harvard Law School and was a Fulbright Scholar. Commissioner Frankel was a Fairfield County resident who appreciated and deeply cared about the beauty and character-defining features of the Merritt, and after his initial reluctance, he rapidly and dramatically changed DOT policy concerning the Merritt.

"The Merritt Parkway is not going to be widened on our watch," Emil Frankel announced in April 1991. This statement ushered in a new era at the DOT. Large-scale projects were shelved, including Super Route 7 and Route 25 from Monroe to Newtown as well as other pricey projects in the state. However, the U.S. 7 expressway was continued for 2.7 miles northward from Connecticut 123 past the Merritt Parkway, where a partial interchange was constructed. A new approach was needed for management of future improvements on the parkway.

In 1992, Commissioner Frankel created the Merritt Parkway Working Group to develop policies for preserving the character of the parkway while improving safe and efficient travel. Members of the group included representatives from the DOT and outside advisors appointed by Commissioner Frankel: Nancy Campbell, trustee of the National Trust for Historic Preservation and consultant to the Regional Plan Association; Herbert Newman, architect at Herbert S. Newman and Partners and Yale School of Architecture faculty member; Shavaun Towers, landscape architect, Rolland/Towers;[101] and later, Jacqueline Salame, preservationist and field supervisor for the Merritt Parkway Historic American Engineering Record project.

The group studied all aspects of the parkway, road design, landscaping, medians, bridges, signage and service areas. The group also had historical guidance on the original design of the parkway with the newly

The new signage, echoing the original saw-tooth design, was installed on the parkway in 1994. *Courtesy of Jill Smyth.*

published report by the federal Historic American Buildings Survey/ Historic American Engineering Record (HABS/HAER—a program to document historic sites). After the Merritt's designation on the National Register, a team of engineers and architects documented the planning and construction of the parkway up to the opening in 1940. The Merritt Parkway project produced photographs, measured drawings and a written

history. The written history, *Connecticut's Merritt Parkway: History and Design*, provided background for the working group in making recommendations on future improvements to the parkway.

The working group was given free rein to examine all aspects of the parkway—repairing bridges, improving the landscape, restoring the service areas, assessing guiderails, redesigning signs and making the ramps and interchanges safer—with the overall goal of saving the Merritt Parkway. During this process, a dialogue between private experts and the DOT staff responsible for the Merritt developed into a strong emotional commitment to preserve the Merritt while "striking the right balance of utility, aesthetic and historic"[102] in creating the guidelines.

There were many improvement projects underway that benefited from advice given by the working group. Bridge design was reviewed and landscaping incorporated into the projects. The working group model was new to the DOT and, in the end, was successful in opening a dialogue that was respectful of the thoughts and experiences of private professionals, DOT engineers and professionals and the Federal Highway Administration. Through this educational experience, a master plan for the Merritt was developed and incorporated into current design plans. The group published three reports that included recommendations for improvements and maintenance on the Merritt.

The *Merritt Parkway Guidelines for General Maintenance and Transportation Improvements* was presented in June 1994. The goal of the working group, as stated in the document, was "to establish the premise that the Parkway is a distinct type of roadway, having an aesthetic as well as a transportation function, and should not necessarily receive the same type of treatments as Connecticut's expressways, particularly in the areas of design and landscaping."[103] To that end, recommendations and guidelines were developed for design standards covering the many elements that contribute to the character of the Merritt.

The Landscape Master Plan was presented in October 1994. The plan documented current conditions and original design details and suggested design treatments for the entire length of the parkway and recommendations for maintenance. *The Merritt Parkway Conservation and Restoration Plan: Bridge Restoration Guide* was published in 2002. The bridge guidelines, similar to the master plan for landscaping, identified current conditions and guidelines for historic bridge restoration.

In the late 1990s, the Merritt's gateways, 2.3 miles in Greenwich and 2.6 miles in Stratford, were improved with the recommendations set forth in the

Left: Merritt Parkway signs are shaped as the Connecticut shield and display the state flower. *Courtesy of Laurie Heiss.*

Below: The Merritt Parkway Landscape Master Plan provides guidance based on the original landscape design, which addresses current environmental and maintenance issues. *Courtesy of the Connecticut Department of Transportation.*

EXISTING

OPPORTUNITY:
Add trees to median where there is adequate width.

RATIONALE:
Bridge approach needs framing. Median trees break up the monotony of long stretches of open areas, reinforcing design identity of the Parkway.

CONCERNS:
Requires new guiderail at edge of median; increase in maintenance between guiderail.

Merritt Parkway Landscape Master Plan State of Connecticut Department of Transportation	CONCEPT MANUAL	4.7.1 2
Median Treatment Vegetation - Tree Addition/Framing Views	Milone & MacBroom, Inc. Johnson, Johnson & Roy, Inc. Johnson Land Design Fitzgerald & Halliday, Inc.	

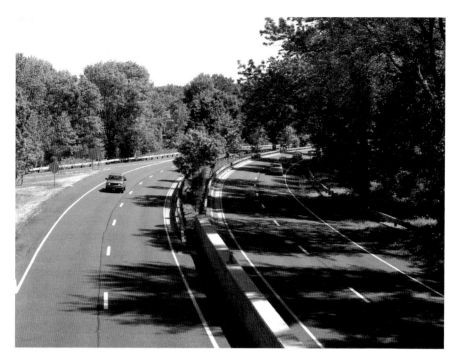

Two types of guiderail were designed for the parkway. The wood-faced, steel-backed rail is similar to the original wood railing. In other areas, low concrete blocks with horizontal banding are used. *Courtesy of Jill Smyth.*

master plan. The most notable design improvement from the guidelines is the guiderails. The steel-backed, timber-faced guiderail, known as the Merritt Parkway Guiderail, was crash tested and approved for traffic volumes and speeds on the parkway. A concrete barrier was also designed by the DOT for use on the parkway instead of the standard-issue Jersey barriers. The railing and other stated guideline improvements from the master plan continued to be incorporated in the safety and enhancement projects planned for the entire length of the parkway.

With Governor Weicker's decision not to run in the next election, it was important to ensure the DOT's commitment in following the developed guidelines on future Merritt Parkway projects. Commissioner Frankel, in June 1994, issued a policy statement stating, "In meeting this policy, all Merritt Parkway transportation improvements and maintenance activities shall be undertaken in accordance with the Department's *Merritt Parkway Guidelines for General Maintenance and Transportation Improvements.*"[104] This type

of policy statement for historic roads was not typical at the time. Within the next few years, other states began issuing policy statements on special treatments of historic roads.

Merritt Receives Designations

In 1993, Governor Lowell Weicker designated the Merritt Parkway a state scenic highway at the Greenwich Tourism Center. The designation requires that the state's Scenic Road Advisory Committee review any significant changes planned for the road. In honor of the occasion, a dogwood was planted and a "state Scenic Highway" plaque was unveiled.

Three years later, in 1996, the U.S. secretary of transportation designated the Merritt Parkway as a National Scenic Byway for its significant and context-sensitive design of integrating road and bridges. The mission of the National Scenic Byways program is to promote and protect unique roads throughout the country.

The American Society of Landscape Architects (ASLA) conferred a Centennial Medallion on the parkway in 1999. The American Society of Landscape Architects' medallion program recognizes public landscapes that are important to their communities and of national significance. Sites were selected nationally with the Merritt Parkway being one of the five sites selected in Connecticut. The other sites in Connecticut were Harkness Memorial State Park, the New Haven Green, Bushnell Park and Seaside Park. The award was presented at a ceremony at the DOT's headquarters in Newington.

The decade began with the emotionally charged issue of widening the parkway, but there was also promise for a brighter future for the Merritt due to its listing on the National Register. The involvement of the Save the Merritt coalitions to stop the widening and the efforts by the Connecticut Trust for Historic Preservation to nominate the Merritt to the National Register of Historic Places once again demonstrated that this is a road valued by Connecticut residents. Governor Weicker's appointment of Commissioner Frankel changed the outdated culture at DOT briefly. Commissioner Frankel's reassessment of decade-old plans and the introduction of professionals from outside the DOT working in collaboration with DOT staff resulted in the specific plans to guide restoration of the parkway.

Federal legislation also assisted in discouraging future widening. The 1991 Intermodal Surface Transportation Efficiency Act (ISTEA) introduced intermodal planning and the tougher Clean Air Act was not conducive to adding additional automobile capacity on the Merritt. However, with the election of Governor John G. Rowland in 1995 and his reappointment of J. William Burns, the commissioner prior to Commissioner Frankel, the Merritt's future would again be in jeopardy.

THE 2000S

*The DOT/Nonprofit Partnership and Standing
Up for the Bridges*

*Car of the Decade: Toyota Prius hybrid
Song on the Car Radio or iPod: "Empire State of Mind" by Alicia Keys and Jay-Z*

The year 2001 seems to be defined by life before and life after 9/11. Over 150 Connecticut residents lost their lives that day, and for some time after, the tri-state area was really one region mourning and recovering together. Governor John Rowland replaced Commissioner Burns with James Sullivan (1997–2002) and then Commissioner James Byrnes Jr., who served until Roland resigned in 2004 during a corruption investigation.

While the Super 7 project and its connection to the Merritt had been shut down by Emil Frankel in the early '90s, along with the Merritt Parkway expansion plans from the "Corridor Study, 2000," the CBET and COMET groups decided that advocating for a trail on the Super 7 right of way was a win-win. They proposed that the right of way should be used for healthy and environmentally friendly recreation. The Norwalk River Valley Trail project is actively creating a multiuse trail from Norwalk to Danbury, which was first proposed in the '70s by Citizens for a Sensible 7. A trail keeps the residents in touch with the land and the landowner, the DOT. Route 7 alternative plans of road widening were successful and nearing completion; the need for a Super 7 expressway became even more baffling in hindsight.

In 2002, historic society of the town of Greenwich (HSTG) preservationists decided to delve back in history and began a search for the Connecticut tercentenary plaque and time capsule, which were buried in 1937 in

Greenwich near the Round Hill Road Bridge during the celebration for the new bridge and the newly landscaped portion of the Merritt. The plaque was affixed to a boulder, which has been found, and the capsule was placed in the roots of a thirty-foot elm tree and has never been recovered. The unveiling ceremony occurred on the unpaved section of the Merritt near the boulder on May 7, 1937. In Greenwich, as the Merritt arrived, there were multiple celebrations: in 1934, the groundbreaking for the Merritt Parkway; in 1937, for additional Merritt progress, a bridge and the tercentenary; and two in 1938, one at the Stamford-Greenwich line and another at the King Street state line.

Continuing his concern for the parkway past his term as commissioner, which ended in early 2006, Frankel started the process of setting up a 501(c) (3) nonprofit organization that might celebrate and protect the parkway, to be called the Merritt Parkway Conservancy (MPC). A project to determine the need, structure and mission for such a conservancy had been funded by a $15,000 grant to the Connecticut Trust for Historic Preservation from the Fairfield County Community Foundation, including portions from the Stamford Community Fund and the Greenwich Community Fund. The study indicated there was need to raise private resources for the road's improvement and oversight, and the study envisioned a nonprofit operating structurally like the Central Park Conservancy on a smaller scale. The trust incubated the fledgling nonprofit.

The initial meeting of the newly formed MPC was in February 2002 with Emil Frankel as chairman. When Frankel accepted a new position in the transportation industry four months later, he had to resign and turned the helm over to Deanne Howard Winokur, who recruited co-chair Peter Malkin, both of Greenwich. Initial projects included a new illustrated *Guide to the Merritt Parkway*, creating a photographic archive; experimental mowing practices at Round Hill Road; and oversight of and meeting with the DOT on the rejuvenated Merritt Parkway Advisory Committee (MPAC) as a stakeholder. Other stakeholders on the MPAC included the Connecticut Trust for Historic Preservation, the American Society of Landscape Architects, architectural representatives from the Connecticut chapter of the AIA, the state historic preservation officer, Southwest Regional Planning Association (SWRPA), representatives from bordering towns and many DOT employees. The meetings were chaired by the senior DOT employee at the meeting, and no votes were taken.

As the conservancy grew with membership and donations, an executive director was hired. Part of the mission of the MPC was outreach and

education, so oftentimes, the executive director was out connecting with many of those same civic groups and garden clubs that had been generous and involved sixty years ago. Some of the older garden club members would share their stories of their earliest memories of the Merritt Parkway.

In 2003, a new commissioner was brought in, something that happened with increasing frequency in the next twelve years. The 2002–03 Road Surfacing, Bridge, Safety Improvement Project was in the Greenwich area, and the conservancy provided landscaping suggestions and asked that some unsightly berms, dirt piles and excess asphalt be removed from the roadside, particularly where the entrance/exit ramps were redesigned. The sixty-fifth anniversary of the Merritt's first opening was also in 2003. Certainly there are multiple dates one could celebrate as anniversaries: first groundbreaking (1934), initial eighteen miles opened and widely celebrated (1938) or the full parkway opening connecting to the Milford Parkway south/east and connecting with rudimentary Wilbur Cross toward New Haven/Hartford (1940). The *New Guide to the Merritt Parkway* was completed and was donated by the conservancy to the service areas and sold in other cultural heritage locations. The guides disappeared from the service areas the first day as a collectible souvenir.

MPC funded a variety of parkway projects, hired experts and gave feedback to the DOT on parkway projects. In 2003, the conservancy commenced the planning and permitting process to light two of the treasured bridges' façades as a holiday gift to commuters. It was like taking two bridges from the Merritt Parkway bridge museum and showing them off. The conservancy professionally lit the façades of two bridges for the dark drive home in December 2004. This seasonal installation, "A Celebration of Light and Architecture," was well received, and the lighting was featured on the front page of the *Boston Globe* Travel section: "…66 years later, Connecticut's Merritt Parkway still offers drivers miles of beauty and stress relief." For the article, reporter Kathy Shorr interviewed Herbert Newman, a New Haven–based architect and architecture critic who taught at Yale for four decades. Newman was also a member of the Merritt Parkway Working Group. He recollected driving to New York with his parents and boisterous siblings on the Merritt and reflected on the Merritt from an architect's point of view:

> *When we came to the Merritt we were distracted from our battles. Here we were on a beautifully landscaped roadway, at that time with marvelous open views. The roadbed was like a ribbon, stretched across the landscape. It was almost like you were on a magic carpet…The wonder of the Merritt*

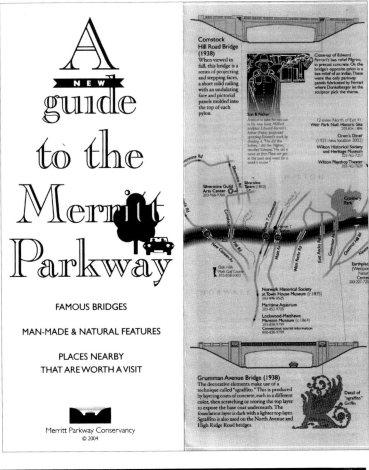

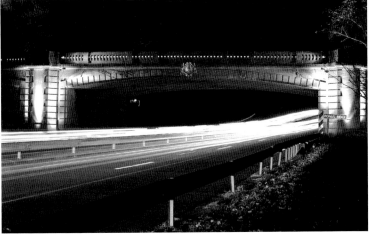

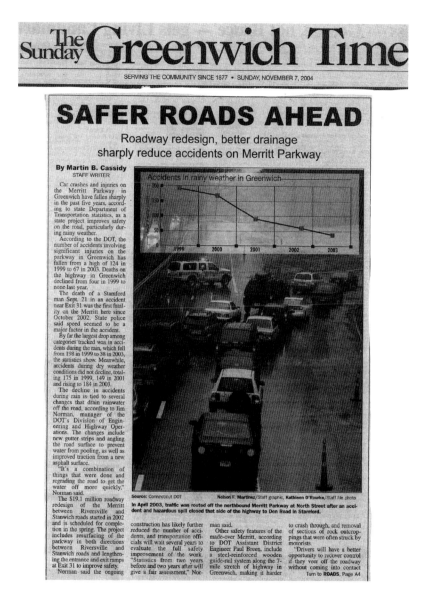

Opposite, top: The Merritt Parkway Conservancy, started in 2002, published the first *Guide to the Merritt Parkway* in over fifty years. *Courtesy of the Merritt Parkway Conservancy.*

Opposite, bottom: The conservancy's seasonal light installation delighted travelers during their evening commute home in December 2004. *Courtesy of Eric Seplowitz, Captured Light Photography.*

Above: The DOT takes to the press to herald its "Resurfacing, Bridge and Safety Improvements" project. *Courtesy of Hearst Conn Media Group, copyright 2004.*

was that it was conceived as a place to experience the state, not just get from here to there. To my mind, it's Connecticut's longest, perhaps most wonderful, work of architecture. The joy of that experience compared to other motoring experiences has always stood out. That's what great works of art do: They renew you and get you in touch with your humanity. The Merritt does that. It's a great work of art, I think.

On the Merritt Parkway in the new millennium, well-designed, safety-motivated enhancements of the entrances/exits, drains, roadbed, railing, shoulders and invasive removal continued. Motorists were happy with the improvements, the wood-backed guiderails and the easier-to-use ramps in most cases. Alongside praise for the DOT were articles about soaring state transportation costs led by fuel and insurance and headlines about DOT employees being investigated for accepting bribes.

ROUTE 7: MERRITT PARKWAY INTERCHANGE REEMERGES

At the MPAC quarterly meetings since about 1994, stakeholders met with the DOT and received updates on current projects with an opportunity for discussion. Reviewing a complex project management visual aid, there was a short discussion about a high-priced project going out to bid for exit improvements and roadbed realignment at Exits 39 and 40. This project, for an interchange with the nonexistent Super 7, was not about improving ramps but rather a large interchange redesign with roadbed realignment and tunnels. There was no supersized traffic volume coming from the existing Route 7. There was no expressway. The interchange project had survived when Super 7 was shelved over ten years ago. Even legislators were caught off guard, trying to remember what public hearings had talked about this project; the most aware members of the public would have thought the remaining interchange, if needed at all, would be downscaled, but most people connected to the long saga of Route 7 thought the whole project had been shelved. But here it was again in 2004.

The massive interchange design, with ramps raised thirty feet above the parkway roadbed, Super 7 lanes tunneling below the Merritt, wholesale landscape destruction and the demolition of three bridges now protected as contributing historic resources, was shocking. But somehow, the project was designed and heading out to bid. The status

change on the overview document indicating a massively expensive project "heading out to bid" was what caught the attention of the stakeholder group. What was this project? How could Connecticut taxpayers need an overlarge interchange with an orphaned section of expressway that went a couple of miles in either direction? Granted, the current highway-to-highway interchange did not provide all directional connections (so that traffic used local roads briefly or Routes 8 or 25 to connect between 95 and the Merritt). But a $100 million interchange to add those connections also enabled the Super 7 expressway for later construction. The chief proponent for the interchange was the mayor of Norwalk (with shades of the Bridgeport controversy). Importantly, with a federally funded project, the historic resource protections of the Historic Preservation Act and the Federal Highway Act provided all Merritt Parkway bridges with legal protections that cannot be bypassed unless all possible planning to minimize harm has been shown as done and alternatives to "taking" a resource have been explored. Connecticut's Environmental Protection Act has additional, similar restrictions that protect culturally historic resources. But these legal protections are really only effective if brought before a judge for enforcement.

In June 2005, the Merritt Parkway Conservancy filed suit against DOT/FHWA to block construction based on federal highway and preservation laws. A number of other organizations joined the suit as co-plaintiffs, including the National Trust for Historic Preservation, the Connecticut Trust for Historic Preservation, the Sierra Club, Norwalk Preservation Trust, the Norwalk Land Trust and the Norwalk River Valley Association. During the early months of the lawsuit, the DOT refused to negotiate but continued, and perhaps speeded up, construction. It started by removing all of the tall and handsome pines lining the Merritt hill heading east and along the ramps. The DOT also decided to remove the rock facing of one of the involved bridges, partially destroying the historic appearance and weakening the structure until the plaintiffs prepared to get an injunction. Threatened by the likely prospect that an injunction would be granted, the DOT halted all construction activity in the area. The old twin Main Avenue overpasses, lined with pines and a commercial but attractive area, now resembled a war zone strewn with construction equipment, riprap boulders, tree stumps, runoff sheeting on stakes and other building materials. The original fieldstones were pried off and then disappeared. It was a long cry from the original bucolic, adorable farm that used to sit delightedly with the Merritt, running calmly through its backfield.

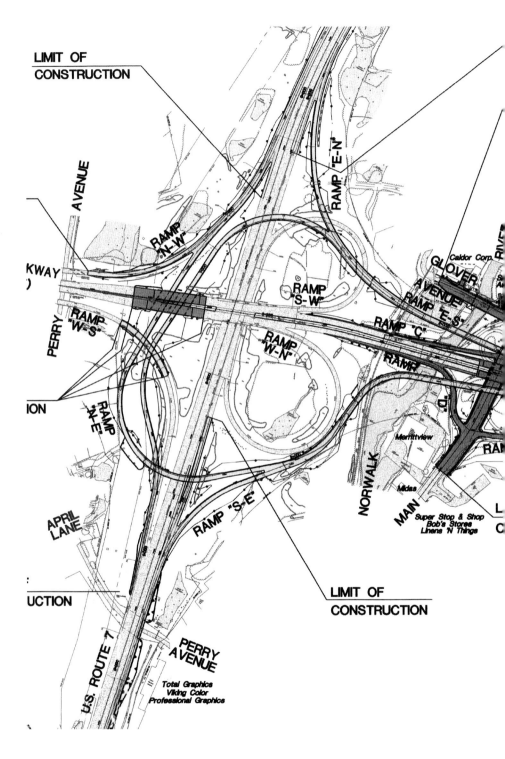

LIMIT OF
CONSTRUCTION

AVENUE

RAMP "E-N"

RAMP "N-W"

KWAY
)

GLOVER

Caldor Corp.

AVENUE

RAMP "E-S"

PERRY

RAMP "S-W"

RAMP "C"

RAMP "W-S"

RAMP "W-N"

RAMP

ION

"D"

RAMP "N-E"

RAM

Merrittview

NORWALK

Midas

APRIL
LANE

MAIN

Super Stop & Shop
Bob's Stores
Linens 'N Things

RAMP "S-E"

L
C

:

UCTION

LIMIT OF
CONSTRUCTION

U.S. ROUTE 7

PERRY
AVENUE

Total Graphics
Viking Color
Professional Graphics

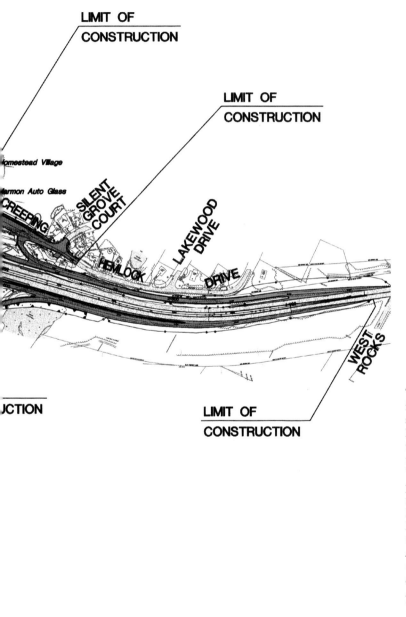

This proposed interchange was stopped by a lawsuit because the DOT failed to demonstrate "all possible planning to minimize harm" to the Merritt Parkway. *Courtesy of the Merritt Parkway Conservancy and Connecticut Department of Transportation.*

131

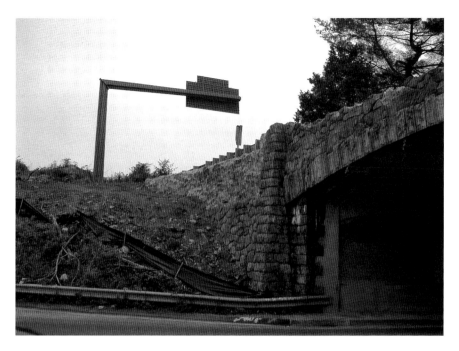

During the lawsuit, stones were removed from this Main Avenue Bridge, forcing the seven plaintiffs to seek an injunction. *Courtesy of the Merritt Parkway Conservancy.*

Opposite: The previously pastoral Norwalk River Valley was heavily developed, and a proposed massive interchange threatened these historic bridges in 2005. *Courtesy of the Norwalk History Room, Norwalk Public Library.*

In March 2006, after the DOT/FHWA turned down the chance to settle, for which the plaintiffs were agreeable and prepared, Judge Mark Kravitz ruled in favor of the plaintiffs, and the interchange as drawn was halted with the judge ordering the parties to try to work together to find a solution to move forward. The plaintiffs' legal, technical and consulting fees were paid by the DOT/FHWA at market rates. In an editorial titled "DOT Must Design and Include," the *Hartford Courant* commented on DOT's intransigency:

> *If nothing else, you have to applaud the state Department of Transportation's tenacity. Department officials are continually criticized for over-designing projects, but they keep doing it anyway. A recent federal court decision about a DOT project on the historic Merritt Parkway in Norwalk is illustrative. The DOT and Federal Highway Administration plan to build*

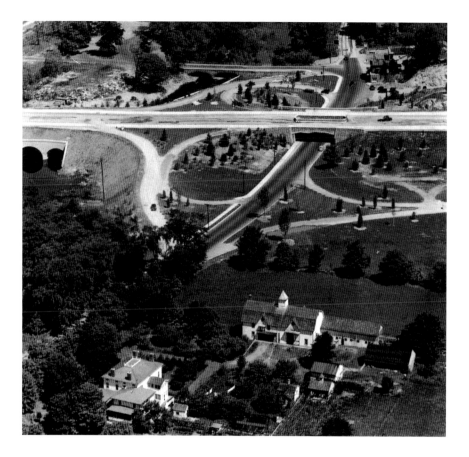

a massive $100 million interchange where the Merritt meets Main Avenue and the nearby Route 7 connector. When community groups got a look at the final plans they were aghast…the interchange was once part of a plan to continue the major "Super 7" highway…although the project was cancelled in the late 1990's, the huge interchange remained, apparently still designed to accommodate the non-existent expressway…Time and again, the department comes in with big, complex designs even for relatively minor road projects, and then sometimes backs off in the face of local opposition. This "design and defend" approach, as the Norwalk case illustrates, is a huge waste of time and money…the DOT has to change its planning process and involve the public from the beginning. Judge Kravitz criticized the department for moving ahead with the Norwalk project although it knew community opposition could lead to a lawsuit and delay.[105]

NATIONAL TRUST *for* HISTORIC PRESERVATION®

NORTHEAST PRESERVATION NEWS

A Monthly Newsletter from the National Trust's Northeast Office

Volume 5, Number 5 www.nationaltrust.org May 2006

Northeast Office
Seven Faneuil Hall Marketplace
Boston, MA 02109
617/523-0885
617/523-1199 (fax)
nero@nthp.org (e-mail)
Serving: CT, ME, MA, NH, NY, RI, VT

Wendy Nicholas, Regional Director
Alicia Leuba, Director of Programs
Roberta Lane,
 Program Officer/Regional Attorney
Rebecca Williams,
 Field Representative
Brent Leggs, Program Assistant

Northeast Field Office
6401 Germantown Avenue
Philadelphia, PA 19144
215/848-8033
215/848-5997 (fax)
nefo@nthp.org (e-mail)
Serving: DE, NJ, PA

Adrian Scott Fine, Director
Neeta McCulloch, Program Assistant

Shared Field Staff
CT Trust for Historic Preservation,
Nina Harkrader, Brad Schide
circuitrider@cttrust.org (e-mail)
860/463-0193

Preservation Trust of Vermont,
Ann Cousins, Doug Porter
ann@ptvermont.org (e-mail)
doug@ptvermont.org (e-mail)
802/658-6647

Northeast Advisors
CT: Preston Maynard, Anita Mielert
DE: Mary Jane Elliott, Joan Hazelton
ME: James Day, Ed Hobler
MA: Robert Kuehn, Marita Rivero
NH: Doris Burke, Martha Fuller Clark
NJ: Diane Allen, Ron Magill
NY: Richard Hawks, Anne Van Ingen
PA: Caroline Boyce, Augie Carlino
RI: Karen Jessup, Richard Youngken
VT: Elizabeth Humstone, Robert
 McBride

Statewide Partners
Connecticut Trust for Historic
Preservation, Preservation Delaware,
PreservatION MASS, Maine
Preservation, New Hampshire
Preservation Alliance, Preservation
New Jersey, Preservation League of
New York, Preservation Pennsylvania,
Preserve Rhode Island, Preservation
Trust of Vermont

Statewide Main Street Programs
CT: Connecticut Main Street Center
DE: Delaware Main Street Program
MA (Boston): Boston Main Streets
ME: Maine Downtown Center
NH: New Hampshire Main Street
 Center
NJ: Main Street New Jersey
PA: Office of Community Development,
 Pennsylvania Downtown Center
VT: Vermont Downtown Program

www.nationaltrust.org

Federal Court Rules on Merritt Parkway Project

We are pleased to report that U.S. District Judge Mark R. Kravitz has ruled in favor of the Merritt Parkway Conservancy, the National Trust for Historic Preservation, the Connecticut Trust for Historic Preservation, and a number of other organizations, in a case challenging the expansion of a double interchange on the Merritt Parkway at Route 7 and Main Avenue in Norwalk. (See the cover story of the July 2005 Northeast Preservation News.)

The court ruled that the Federal Highway Administration and the Connecticut Department of Transportation (ConnDoT) failed to show that the interchange project included "all possible planning to minimize harm" to the historic Merritt Parkway, as required under Section 4(f) of the Department of Transportation Act of 1966. As a result, the court ordered the project remanded to the federal and state transportation agencies to cure the legal "defects" identified by the court.

Winding through 37.5 scenic miles, the Merritt Parkway is listed on the National Register of Historic Places and is designated a National Scenic Byway and a State Scenic Road. Built between 1938 and 1940, the Parkway was originally graced with 69 ornamental bridges and more than 70,000 ornamental trees and shrubs.

The proposed interchange would include 21,300 feet of new ramps, 2,359 feet of new roadway, and several elevated flyway ramps. It would destroy four historic bridges and nearly a mile of mature landscaping along the Parkway, in order to construct massive new elevated ramps that are inconsistent with the scale and historic character of the Merritt Parkway. The interchange design was originally created when plans were underway for a new "Super 7" freeway extension to the north. That project was later cancelled, but the new interchange remained supersized despite the now defunct freeway project.

Working in partnership with the Trust's Law Department and many local organizations, the Northeast Office first tried to craft a compromise with ConnDoT to avoid litigation. Upon failing that, there was no choice but to pursue the legal opportunities presented by the flawed process in this case.

The National Trust and the Connecticut Trust view this court ruling as an opportunity for federal and state transportation leaders to move forward and work together with the public to make the interchange project one that demon-

A view along the Merritt Parkway. photo: Tod Bryant

strates that safety, efficiency, history and landscape can work in harmony.

"We brought this lawsuit both because we care deeply about protecting the historic character of the Merritt Parkway and because we believe that the values of preserving this magnificent roadway are fully reconcilable with the needs of a 21st-century transportation system," said Richard Moe, president of the National Trust for Historic Preservation. "In the past, ConnDoT has demonstrated commendable leadership in managing the Merritt Parkway as a modern transportation facility without destroying the qualities that make it a national treasure. The court's ruling provides an opportunity for ConnDoT to show the same kind of leadership in re-thinking the interchange project."

"The National Trust and our local and state partners stand ready to roll up our sleeves and sit down with the transportation agencies to make this project a model, which can demonstrate that sensitive design and safety are compatible, not mutually exclusive," said Elizabeth Merritt, Deputy General Counsel for the National Trust. "We hope this court decision will lead to a constructive dialogue about how to minimize harm to the Merritt Parkway that engages the public and state historic preservation officials."

"This decision presents preservationists and transportation officials with a wonderful opportunity to work together as we have in the past to protect and preserve the historic integrity of the Merritt Parkway while improving it for a new century," said Helen Higgins, Executive Director of the Connecticut Trust. "We are convinced that the Route 7 Interchange project can move forward in good time, with only a few modifications to better respect the Parkway's historic bridges and landscape."

Judge Mark R. Kravitz ruled in favor of the conservancy, the National Trust for Historic Preservation, the Connecticut Trust for Historic Preservation and other plaintiffs in 2006. *Courtesy of the National Trust for Historic Preservation and Tod Bryant.*

While preparing three litigators for trial, finding expert testimony, doing discovery on DOT files and coordinating the co-plaintiffs, the conservancy also managed improvement projects on the Merritt. With permission and permits, the conservancy hired tree experts to remove over a mile of invasive species in New Canaan, and all parties learned more about the best way to accomplish this with machinery. The conservancy researched the original six clocks in the service areas and assessed each of the old timepieces. Projects by the DOT on the road required constant meetings and input, sometimes even expert help. The MPC provided input to projects at the North Street interchange (Greenwich), on the Frenchtown Bridge façade breakage repair (Trumbull) and at the Long Ridge (Stamford) interchange renovation. Re-landscaping was an integral part of the interchange projects. The conservancy had landscape architects on retainer who had a deep knowledge of what the Landscape Master Plan said and knew how to interpret the strategies and examples. Each project benefited from these professional landscaping suggestions, when they were accepted.

A few times each year from 2003 to 2005, conservancy staff (including the authors), the landscape consultants and a DOT team that included its district manager, maintenance chiefs, landscape designers and engineers would jump in a big van and slowly drive the Merritt noting landscaping issues—leaning limbs, invasive strongholds and dead trees or shrubs—and making suggestions. We would stop at Lakeside Diner, just north of the Merritt at the Long Ridge exit in Stamford. This diner—yes, which overlooks picturesque Holts Pond—has been there since 1951 and the early motoring days, and somehow it was a fitting tribute to the history of the road, the predecessors of this DOT team and those historic tourist spots that have survived. You certainly get the comfort food and the old-fashioned feel of the pleasurable motoring days of the parkway when you stop here.

The incremental changes in the parkway's landscape prompted the conservancy to dedicate its 2006 annual meeting to a panel discussion entitled "How the Landscape Has Changed." Concern was growing with all these safety projects and the attendant landscape disfigurement being planned and already happening all along the parkway. With each project, a piece of the intangible landscape was taken away and it wasn't replanted with the same genius, eye and sensibilities as the original father of the landscape. Some replantings were haphazard, some died and some resembled soldiers instead of grouped, naturalistic clusters. Conservancy members didn't know what was ahead or that it would suddenly get much worse. The conservancy was invited for tree inspections because the DOT wanted to expand the

roadside buffer from eight to twelve feet, which meant hundreds of trees would be removed. This was in response to a tree falling onto a car on the parkway with two fatalities. In the Stratford right of way, the DOT decided to remove about two hundred supposedly hazardous trees.

Still in 2006, there were a number of less serious endeavors involving the Merritt that were part of the conservancy's mission statement of celebrating the road. The conservancy had an all-school assembly at Whitby School, very near the parkway in Greenwich, and gave a history and science lesson, varied by age group, around the parkway. Further, professional boutique coloring books about the Merritt Parkway had been produced for this and other youth-oriented events in order to charm another generation with the stories of the roadway and to build awareness among children about the delightful bridges and fun history of this special road. In a move aimed to be at least as fun, the conservancy opened a museum in the lobby of a Stratford building owned by board members Robert and Catherine Sbriglio. It was fantastic to display some of the memorabilia with which the conservancy had been entrusted over the years from the many Fairfield County residents who had family members involved with the Merritt. Old movie reels, many photo donations, ephemera and wonderful stories had come to the conservancy over nearly five years. The opening was a delightful celebration, with classic cars from near and far, barbershop quartets and great enthusiasm for the computerized presentation and the artifacts inside the museum. The conservancy also contributed to a professionally curated exhibit at the Greenwich Historical Society about design in the town, and the Merritt's context-sensitive design was explored, explained and illustrated for all to enjoy.

In a perhaps less fun involvement, the conservancy was asked to review a huge project in Westport—the YMCA relocation very near an exit in Westport, requiring landscape removal and construction and a significant altering of the view shed in an otherwise nice stretch of the Merritt. The traffic projections of the facility would force alterations at the exit and traffic light virtually at grade, close to the parkway. The parkway is not lit and has never been lit (except gently at service areas), and the visual pollution of at-grade traffic lights and this building would be evident to all motorists. It is hard to picture just where the DOT's 150-foot right of way is in this area being developed alongside the Aspetuck River. Motorists and preservationists hope for well-executed and quick-growing landscaping to shield the intrusion.

In another difficult project, the DOT decided to remodel and enlarge a maintenance facility behind the service area in New Canaan; this building

had experienced a fire and needed updating. Further, the DOT intended to build a new salt shed, higher, wider and sitting on higher land than the existing salt shed. Conservancy-affiliated architects and landscape architects attempted for well over a year to influence the design and location of the huge facility, which they expected to be built on I-95, not on the parkway. The much larger trucks needed to be able to tilt up inside the building, or so concerned neighbors were told.

In 2008, there was yet another new DOT commissioner, the fourth since the conservancy started, and there was yet another anniversary celebration, the seventieth, replete with a classic car convoy, speeches from dignitaries and old-fashioned good fun—again in Stratford near the Housatonic/Sikorsky Bridge. And speaking of the Sikorsky Bridge—so named for aviation pioneer Igor Sikorsky and his helicopter business—Sikorsky Aircraft Corporation sits at the foot of the northwestern corner of the so-named bridge and has since the 1950s. Still today, commuters and visitors can look down from the elevated bridge onto the helipads at Sikorsky, and often there are aircraft coming and going and being tested there. A concrete deck carrying three lanes in each direction and a sidewalk for pedestrians finally replaced the original open metal bridge in 2007. The original metal bridge was demolished. Decorative touches included wrought-iron railings and period lighting. The new bridge was formally dedicated as the Igor I. Sikorsky Memorial Bridge, with speeches, a celebration and the lieutenant governor rendering praise alongside the DOT deputy commissioner.

Ironically, seventy years after the Merritt Parkway was constructed without federal assistance, the DOT received $60.6 million in federal funding for a nine-mile upgrade of the parkway. The Resurfacing, Bridge and Safety Improvements in the Towns of Fairfield and Trumbull were "shovel ready" and qualified for the American Recovery and Reinvestment Act infrastructure funding. Vice President Joe Biden, U.S. senator Chris Dodd and U.S. representative Jim Himes announced funding at an October 2009 press conference at the Easton Turnpike Park and Ride Lot.

The vice president noted Schuyler Merritt's remark that the parkway was "not being constructed for rapid transit, but for pleasant transit. Well, I'm guessing he would be pretty shocked by what constitutes rapid today. It is still very pleasant, but it would be nice to get it a hell of a lot more rapid than it is!"[106]

The Fairfield/Trumbull multi-year project, beginning at Congress Street and ending near Exit 51, included the cleaning and restoration of thirteen bridges, replacing one bridge, drainage improvements,

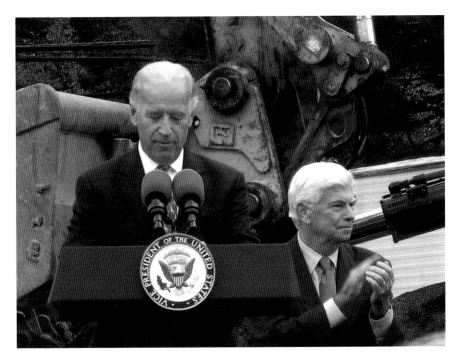

Vice President Joe Biden (at podium) and Senator Christopher Dodd announce federal funding through the Reinvestment Act to revitalize nine miles of the parkway in Fairfield and Trumbull. *Courtesy of Jill Smyth.*

Opposite, top: This image shows the Morehouse Highway Bridge in Fairfield prior to restoration. *Courtesy of Jill Smyth.*

Opposite, bottom: The restoration included concrete repairs, graffiti removal and new plantings to frame the view of the bridge. *Courtesy of Jill Smyth.*

shoulder widening, guiderail replacement, invasive removal, landscaping and repaving. The DOT did a tremendous job ensuring the bridges were correctly restored, matching the colors, textures and finishes. The additional time spent between DOT contractors and specialists and the conservancy and its paid consultants highlighted the original beauty of the bridges. The Road Surfacing, Bridge, Safety Improvement Project program will continue in the towns of Stamford, New Canaan, Norwalk and Westport over the next ten years. The Fairfield/Trumball activities also included cutting thousands of trees. The DOT cited several reasons for the removal of unsafe trees, including to improve sightlines and shoulders and allow for drainage.

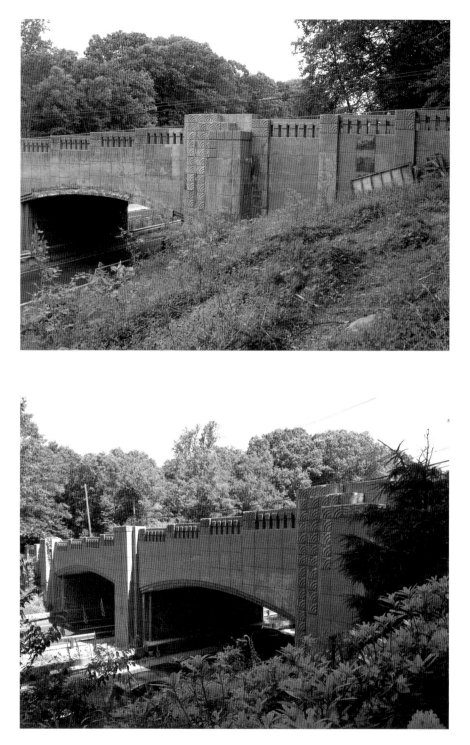

There was widespread objection to the tree removal. Letters and e-mails were sent to the governor, legislators, the DOT and the press. The Merritt Parkway Conservancy hosted a meeting with Commissioner Marie, state historic preservation officer Bahlman, representatives from the National Trust for Historic Preservation, the Connecticut Trust for Historic Preservation, the Connecticut Chapter of the American Society of Landscape Architects and other interested stakeholders to discuss the impact on one of the character-defining features of the parkway. While Connecticut finally got its share of road funding for the Merritt Parkway, the DOT's harsh grading and tree-clear-zone policy has irrevocably changed the intimacy of the road in a landscape that was worthy of funding and, more importantly, provided enjoyment to generations of Connecticut residents, tourists and motorists just passing through. It's hard to put a price tag on the value of that for millions of motorists and commuters.

10

THE 2010s

Does the Merritt Look Different to You?

Car of the Decade: Tesla Model S
On the Car Radio: "Everything Has Changed" by Taylor Swift

The Merritt is getting much-needed attention. The parkway bridges were included on the 2010 World Monuments Watch List due to deteriorating conditions. The watch list brings attention to heritage sites by raising awareness of the sites' significance and the challenges of preservation. Others on the 2010 list included Machu Picchu, Bhutan's Phajoding monastery and ninety others in forty-seven different countries.

Later in the year, the Merritt Parkway was named to the National Trust for Historic Preservation's 2010 List of America's Eleven Most Endangered Historic Places. The Merritt's character-defining features—the bridges and landscape—are at risk of being lost due to lack of maintenance and design changes to modernize the parkway. DOT commissioner Joseph Marie noted the challenges of maintaining the Merritt and the department's commitment to be a steward of the parkway at the press conference held on the North Avenue Bridge in Westport. Peter Malkin, chairman of the conservancy, reaffirmed the Merritt's nomination: "It's an important recognition because it is a tremendous asset to the state and one that is always facing some type of challenge."[107]

The battle to protect the parkway's greenbelt continues. Because of the perceived lack of recreational open space in Fairfield County, the right of way's unused land is looked on as available land by special interest groups. For example, to solve the problem of finding a location for a dog

A press conference on the North Avenue Bridge in Westport announced the inclusion of the parkway on the Eleven Most Endangered Historic Places by the National Trust for Historic Preservation in 2010. *Courtesy of Dave Matlow/WestportNow.com.*

park, language was buried in a bill at the end of the Connecticut General Assembly's 2012 session that gave away two acres of the Merritt's land to the Town of Stratford. Fortunately, the DOT introduced a bill in the next session reversing the legislation. Another section of the right of way was leased to a contractor to stockpile massive piles of sand and soil during construction on land adjacent to the parkway. This is the type of site we might expect to see on the interstate, not as part of the Merritt's landscape.

The DOT applied for and received a National Scenic Byways grant to determine whether a multiuse trail is feasible in the right of way. The federally funded $1 million study includes site analysis, trail alignment in the right of way and design treatments. Once again, the cultural landscape of the Merritt is threatened because of its greenbelt. Advocates champion the idea of an east–west trail as the panacea for reducing traffic congestion and air pollution, improving the quality of life in Fairfield County, stimulating the economy, reducing obesity and serving as a vital link in the East Coast Greenway trail from Maine to Florida for a select few users of the trail.

The current trail design is analogous to adding another traffic lane. The trail would consist of a ten-foot-wide asphalt strip of pavement, two two-foot

shoulders and a six-foot fence on both sides of the trail, running its length. Preliminary concepts for building an ADA-compliant trail will require cuts and fills, switchbacks to meet grade requirements, use of boardwalks to cross wetlands and the construction of several tunnels and bridges—all of this at a staggering price tag of $200 to $250 million. The way in which we experience the parkway today would be a drive of the past. Instead, we could look forward to thirty-seven and a half miles of newly landscaped fencing, bordering a lane of asphalt.

DELIGHTFUL SERVICE AREAS

Project Services, LLC, a joint venture between the parent company of Subway and the Carlyle Group, entered into a thirty-five-year lease to renovate and operate the service areas in Connecticut. As part of the lease, the six service area stations on the Merritt are being restored. Project Services, the DOT and the conservancy have been working on the project since 2009.

The service areas built in 1940 were renovated and expanded in 1958 and remodeled again in 1988. As a result of all the renovations, many of the original details of the buildings have been removed or altered. With the professional talents of conservancy board member architects Herbert Newman and David Scott Parker, the service areas have been restored in keeping with the character of the Merritt Parkway.

The gas canopies have been moved away from the fronts of five of the buildings, opening their charming features, formerly blocked by the gas dispensers, to view. The cumbersome pitched-canopy design has been redesigned to gracefully blend into the surrounding landscape. The exteriors of the buildings were cleaned and the brickwork repointed. The storefront windows were replaced with true divided-light windows, wooden trim and molding replicated to the 1940s original design, and the slate roofs were replaced in kind.

Project Services and the DOT have been excellent partners in the renovation process. To the credit of Project Services, advertising and exterior lighting has been kept to a minimum. It is the Merritt's good fortune to have stakeholders that respect its history.

Severe weather events have had a devastating impact on the landscape. Three recent storms—2011 Tropical Storm Irene, the October Nor'easter in 2011 and Hurricane Sandy in 2012—toppled hundreds of trees. More

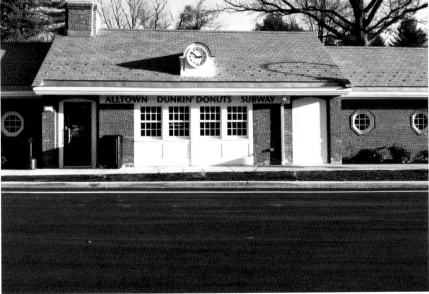

Opposite, top: Before: The service areas were no longer inviting due to decades of heavy use and minimal maintenance. *Courtesy of Jill Smyth.*

Opposite, bottom: After: The charm of the original building and details are once again visible, including the working clock. *Courtesy of Jill Smyth.*

Above: More than four hundred trees were lost on the parkway during Hurricane Sandy in October 2012. *Courtesy of the Connecticut Department of Transportation.*

than four hundred trees came down during Hurricane Sandy, and many of the uprooted trees remain in the right of way today.

The Merritt was ordered closed during the storms due to the trees falling into the road, leaving I-95 as the only major corridor for emergency vehicles. As a result, the DOT ordered all trees within thirty feet of the edge of the road to be removed. Thousands of trees have been removed and the areas left bare. The DOT has stated that there is no funding currently available to replant the areas.

In an effort to restore the barren areas, the conservancy prepared an application for funding through the Connecticut State Historic Preservation Office on behalf of the National Park Service for a Hurricane Sandy Disaster Relief Assistance Grant for Historic Properties. The amount of the grant

requested was $500,000. As part of the application, a preservation restriction easement for twenty years would be placed on the Merritt Parkway. The easement offers basically the same protections already afforded the Merritt. The DOT felt the easement might interfere with future landscaping plans and would not support the application; therefore, it was not submitted.

In the middle of this decade, the results have been mixed. On the preservation of the bridges and restoration of the service areas, the DOT receives good marks. However, on the landscaping front, nothing is being replanted to restore the large swaths of discarded woodchips and overgrown weeds alongside the road. The landscaped borders of the road have always defined the view. This may be the last chapter in the Merritt Parkway as a beloved alternative to I-95 unless funding is secured—and soon.

Conclusion

Pleasant Transit

The Merritt Parkway was constructed when widespread unemployment underscored the gratefulness, joy and pride many workers found in the complex and difficult tasks of forging this road through protected backyards and wilderness. This esprit de corps, the fierce civic pride of the county residents and financial creativity in tough times all contributed to an enduring legacy to those times of pulling things together with grace. At the time the parkway was built, the Fairfield County Planning Association weighed in on the planning of the road in order to control Fairfield County's natural resources and protective enclave. State legislators, civic organizations and the public all weighed in on the construction of the road—from the anti-billboard campaigns to demanding that the road built reflected Fairfield County's individuality and was of the highest quality. The highway department took a calculated but creative approach in building a highway that respected the surrounding landscape and enlivened the drive with an eclectic collection of what became world-renowned bridges. It was the collective imaginative insights of many organizations and individuals that created the parkway. In the 1920s and 1930s, their input was valued, considered and, where possible, incorporated in the plan. This is less true today. Over time, we have seen a shift from collective problem solving to an engineered solution.

In the 1940s and mid-1950s, citizen participation was welcomed at the highway department. For example, garden clubs promoted roadside beauty with plant donations, and the Merritt Parkway Commission made

autonomous decisions. By the end of the 1950s, the highway department had changed, perhaps becoming more autocratic. The department supported, if not instigated, the dissolution of the Merritt Parkway Commission of concerned citizens. The building of the Connecticut Turnpike was devoid of the care shown in building the Merritt, and the participation of residents was limited; the outcome was average, and the process did not incorporate the character-defining features of Connecticut. Gone were the creative talents and skilled artisans from the highway department. The new turnpike was utilitarian and functional, a sign of the times.

Fairfield County has always recognized what is now called a sense of place. It is cherished and heralded. Author Kent C. Ryden described the phrase "sense of place" as something that "results gradually and unconsciously from inhabiting a landscape over time, becoming familiar with its physical properties, accruing a history within its confines." The Merritt Parkway is a defining feature of Fairfield County's sense of place, and it should not be a shock that people believe in protecting the parkway. What is atypical is that it is a road, not a building or a natural resource, which are more typically associated with public outcry for protection.

Plans for widening, adding massive interchanges and destroying bridges unnerved the thousands of citizens who viewed this as an unraveling of the sense of place they valued. Suddenly, part of the daily rhythm of experiencing Fairfield County was to be destroyed. The parkway could, and may, become homogenized, an "anywhere USA" roadway. From the late '60s through the '90s, residents, instead of expecting that the DOT would deliver treatment that reflected the wants of the taxpayers, came to the cynical conclusion that the DOT had hidden agendas, used road safety rules instead of creative compromises, tried to hide its intentions, used confusing language and began to dictate policy affecting the aesthetics of an entire region.

Once citizens became organized, questioned the assumptions and pieced together the detrimental consequences to the Merritt and to Fairfield County, they resolved to stop or alter those planned projects. As the chairman of the Save the Merritt Association noted to commissioners and governors, citizen input early on would have produced a better result and avoided the cost of redesign and public confrontation and would have spared residents countless thousands of hours overseeing a potentially out-of-control road-building process. One would have thought that the DOT would have learned from its first legal setback in 1970. Organizations do not have institutional memory and do not learn easily. But consider the waste of this nontransparent process that delivers one-sided projects requiring citizen opposition to incorporate

the users' input, often invoking the legal system to get the attention of the bureaucracy that, in theory, works for us.

Engineers drive the projects, work around federal laws that might hamper their plans and invoke the highest level of "road standards" that could be mitigated. Is their goal to protect the character of the parkway and Fairfield County's sense of place or to build as much as their allotted federal road funds might allow? A process ending in larger, overcapacity road structures is certainly pleasing to the construction industry.

As Vincent Scully, noted architecture author and longtime Yale professor, stated after reviewing a Connecticut corridor study in the 1990s, "In my opinion, so-called traffic experts are so specialized that they haven't any idea what they're talking about and are a danger to the structure of the state as a whole."

Hopefully, the reasons to save the Merritt are now readily obvious: it is a road that invited, carried and united those suburban people who planned and then made Fairfield County one of the fairest regions, anywhere. In a county that lost its legal status in 1960, the Merritt is the backbone and front entrance to a special place.

We believe the public is in favor of keeping the Merritt a special place. As the current custodians of this remarkable road, people well beyond the Merritt Parkway Conservancy and including representatives of the surrounding towns need to continue to advocate for *their* road. We hope these stories about the Merritt inspire the next generation of travelers, designers and planners to preserve the beauty of the Merritt.

Quite possibly I dozed off. Waking, I found myself in wonderland…a landscape as civilized as any in the paintings of Claude Lorrain or the English parks designed by Capability Brown. Trees were heavy with blossom. Great sheets of water knew their place as momentary vistas. Birds dived and swooped, unhurriedly. Perfumed breezes flowed in and out of our open windows. Stone bridges—no two of them alike—straddled the road. Hardly a house was to be seen, and I pictured Connecticut as a tamed, unending forest inhabited by wise men and beautiful women in comfortably small numbers.

"Where are we, anyway?" I said. "Are these green acres in thrall to Privilege? How come they let us in?" And when they told me that this

was the Merritt Parkway, a public road open to all on payment of a fee in pennies, I thought that they had to be putting me on. Be that as it may, the Merritt Parkway stayed with me as a masterpiece of pacific invention. It was never too wide, too flat, too straight, or too fast. Never repeating itself, it gave nature her very best shot.

Not so long after that, I came to have the Merritt Parkway as my private drive. Other people were admitted, of course, after a pause at the tollbooth, but I saw the Merritt as the extension of my unmarked and almost clandestine driveway. My happiness as a Connecticut resident was—and still is—bound up with its blissful rise and fall. Its discrete but consummate housekeeping, and its knack of editing out the developer in all his works. Who needs 10,000 feudal acres when the Merritt leads almost to his door?[108]

Of all the important roads in the world, the Merritt is the epitome of a road that shaped a region, and as in the past, hopefully it will continue to be the people that shape *their* road.

NOTES

1. Declaration of Paul Daniel Marriott, filed September 7, 2005, U.S. District Court for the District of Connecticut, C.A. No. 305CV860 (MRK), *Merritt Parkway Conservancy, et al., Plaintiffs v. Norman Mineta et al., Defendants.*
2. *New York Times* editorial, October 30, 1963. This article is from before the National Historic Preservation Act was enacted by President Lyndon B. Johnson in 1966
3. Larry Larned, *Traveling the Merritt Parkway* (Charleston, SC: Arcadia Publishing, 1998), 110.
4. Helen B. Kitchell, scrapbook, Greenwich Historic Society.
5. Warren M. Creamer, "The Merritt Parkway," *Connecticut Highways*, July 1962, 4.
6. John A. Macdonald, "Highway Commissioner's Report on the Highway Department and Merritt Parkway to the Governor," State Highway Department, 1938.
7. *Bridgeport Post*, "Merritt Road 10 Years Old as Project for the County," June 1, 1935.
8. Gabrielle Esperdy, "Connecticut's Merritt Parkway: History and Design, National Park Service," *Historic American Buildings Survey/Historic American Engineering Record*, National Park Service (Summer 1992): 15–16.
9. A. Earl Wood, "The Merritt Parkway History and Plan," *Connecticut State Journal* 2, no. 8 (August 1935): 34.
10. Esperdy, "Connecticut's Merritt Parkway," 64.

11. Helen B. Kitchell, 1934 unknown newspaper article, scrapbook, Greenwich Historic Society.

12. John Macdonald, "The Merritt Parkway," address before the Connecticut Society of Civil Engineers, Inc., Stamford, Connecticut, September 30, 1937, 31.

13. Esperdy, "Connecticut's Merritt Parkway," 22.

14. Earle W. Osterhoudt, "Merritt Parkway Speed Study," State Highway Department, 1947, 5.

15. Ibid., 9.

16. Esperdy, "Connecticut's Merritt Parkway," 69.

17. Osterhoudt, "Merritt Parkway Speed Study," 10–15.

18. Esperdy, "Connecticut's Merritt Parkway," 50–52.

19. L.G. Sumner, "Bridges on the Merritt Parkway," *Engineering News-Record*, September 23, 1937, 503.

20. "Rigid Frame Bridges," http://www.marylandroads.com/OPPEN/IX-RgdFr.pdf (accessed June 9, 2014).

21. Esperdy, "Connecticut's Merritt Parkway," 77–79.

22. Helen Binney Kitchell, "The Story of the Merritt Parkway," part 4, *Greenwich Press*, April 14, 1938.

23. *Greenwich Press*, February 28, 1936.

24. Merritt Parkway Conservancy, "A Guide to the Merritt Parkway," 2004.

25. George L. Dunkelberger, "Design of Merritt Parkway Bridges," *New England Construction*, February 1937, 7.

26. Esperdy, "Connecticut's Merritt Parkway," 82.

27. Dunkelberger, "Design of Merritt Parkway Bridges," 8.

28. Catherine Lynn, "The Merritt Parkway-A Road in a Park," *The Merritt Parkway, New Canaan Historical Society Annual* (1990–91): 36.

29. Dunkelberger, "Design of Merritt Parkway Bridges," 8.

30. Sumner, "Bridges on the Merritt Parkway," 504.

31. Esperdy, "Connecticut's Merritt Parkway," 84.

32. Ibid.

33. National Register of Historic Places Nomination, U.S. Department of the Interior, March 5, 1991.

34. Esperdy, "Connecticut's Merritt Parkway," 83.

35. *Connecticut Post*, March 15, 1998, A3.

36. Catherine Lynn, "Edward Ferrari's Sculpture on the Merritt Parkway," *Connecticut Preservation News* (September/October 1991): 3.

37. Lynn, "Merritt Parkway," *The Merritt Parkway New Canaan Historical Society Annual*, 39–40.

38. Dunkelberger, "Design of Merritt Parkway Bridges," 9.

39. Esperdy, "Connecticut's Merritt Parkway," 88; Lynn, "Edward Ferrari's Sculpture."

40. Esperdy, "Connecticut's Merritt Parkway," 86–88.

41. Dunkelberger, "Design of Merritt Parkway Bridges," 10.

42. Catherine Lynn and Christopher Wigren, "Thayer Chase: Landscape Architect of the Merritt Parkway," *Connecticut Preservation News* 14, no. 1 (January/February 1991): 5.

43. Esperdy, "Connecticut's Merritt Parkway," 55.

44. Ibid., 106.

45. Ibid., 108.

46. A. Earl Wood, "Development of the Merritt Parkway," *Connecticut Woodlands* (September 1937): 4.

47. *Bridgeport Post*, "State Retains Natural Beauty in Landscaping Parkway," August 25, 1940, B-2.

48. W. Thayer Chase, "Recollections," undated.

49. *New York Times*, "Connecticut Opens Merritt Parkway," June 30, 1938, 25.

50. *Greenwich Press*, July 18, 1940.

51. Story told by Fairfield Garden Club member at 2004 meeting with the Merritt Parkway Conservancy.

52. Warren Creamer, "The Merritt Parkway, Queen of the Turnpikes," Connecticut Highway Department publication, July 1962.

53. Story from friend of the authors'.

54. *Bridgeport Telegram*, "$150,000 for Parkway Museum; Melton Sings to State Senate," June 6, 1945.

55. Timothy Dumas, "The Soul of Round Hill," *Greenwich Magazine*, April 4, 2001.

56. *Bridgeport Telegram*, "Four Killed When Auto Hits Truck on Parkway," June 15, 1945.

57. Page H. Dougherty, "Capital of the Overall Set: It Is Fairfield County," *New York Times*, September 15, 1946, 45.

58. *Bridgeport Telegram*, "Parkway Called Inadequate Now," January 16, 1952.

59. *Bridgeport Post*, "More Policemen Sought to Patrol Merritt Parkway," February 14, 1959.

60. Ibid., "Autoists Watch Coming, Going in Crackdown on Parkway Speed," January 26, 1952.

61. *New York Times*, "Ribicoff of CT Dies; Governor and Senator was 87," February 23, 1998.

62. Report of James K. Williams, May 24, 1957, Connecticut Governor Records, Abraham Ribicoff, Connecticut State Library.

63. Theodore Watson to Newman E. Argraves, ibid.

64. *New York Times*, "Line on Road's Edge Is Cutting Accidents" January 5, 1955.

65. Abraham Ribicoff to Theodore Watson, December 13, 1957, Connecticut Governor Records, Abraham Ribicoff, Connecticut State Library.

66. Newman E. Argraves to Abraham Ribicoff, April 8, 1958, ibid.

67. "The Connecticut Floods of 1955," Connecticut State Library, http://www.cslib.org/flood1955.htm (accessed June 30, 2014).

68. *New York Times*, "Restaurant on Merritt Parkway Is Fought by Family in Fairfield" February 5, 1960.

69. Theodore Watson to Governor Ribicoff, August 17, 1959, Connecticut Governor Records, Abraham Ribicoff, Connecticut State Library.

70. Herbert Janick, "Connecticut: The Suburban State," *Connecticut Humanities News Council* (Fall 1993), essay written earlier.

71. A.C. Spectorsky, *The Exurbanites* (Philadelphia, PA: J.D. Lippencott Company, 1955), 29.

72. Mary Anne Guitar, *Property Power* (New York: Doubleday and Company, Inc. 1972), all excerpts taken from Chapter 3, "One Town's Triumph."

73. Ibid.

74. *Bridgeport Post*, "$16.3 Million Is Proposed to Improve Area Merritt Parkway Interchanges," January 14, 1969.

75. Bo Mitchell, "Super 7: A Real Threat Then, Unfathomable Today," *Wilton Bulletin*, http://www.wiltonbulletin.com/129/super-7-a-real-threat-then-unfathomable-today (accessed August 1, 2014).

76. Michael Knight, "Report Asserts Fairfield Needs No New Expressways for Years," *New York Times* February 13, 1975.

77. Ibid.

78. Package of information prepared by Dr. Lisa Newton, secretary of Save the Merritt Association, for the new commissioner, James Shugrue, notes and copies regarding the formation, early months and early correspondence of the Save the Merritt Association (1973–75).

79. Ibid.

80. *New York Times*, "Connecticut in Concrete," November 19, 1973.

81. John P. Kelly, "Meskill Orders Speed Up on Plans for Parkway, Rtes 25–8 Linkages," *Bridgeport Post*, January 14, 1974, 1.

82. Save the Merritt "Broadsheet," spring 1974.

83. Newton package of information.

84. *Greenwich Time*, January 13, 1967.

85. *Sensible 7 Times Newsletter*, 1987.

86. Diane Selditch, "DOT to Halt Roadwork on Super 7," *Stamford Advocate*, May 5, 1987, A1.

87. Ibid.

88. Catherine Lynn, "Saving the Merritt: Draft Guidelines Mark Progress, Except on Really Big Issues," *Connecticut Preservation News* (November/December 1993).

89. *Daily Mail*, "Entrepreneur's $162m Estate 'Entirely Eaten Up by Lawyers After 26-Year Court Battle Over His Will," http://www.dailymail.co.uk/news/article-2157948/F-Francis-Hi-Ho-DAddarios-162million-estate-drained-funds-26-years-Connecticut-court.html#ixzz38hrH1ciq (accessed July 27, 2014).

90. Lisa Marie Petersen, "Businessmen Endorses Wider Merritt Parkway," *Stamford Advocate*, June 19, 1985.

91. Ibid.

92. *Bridgeport Post*, "Parkways to Stay Scenic Roads," June 26, 1988.

93. Ibid.

94. Richard Madden, "Old Tollbooths on Merritt: Trying to Save 30's Artifacts," *New York Times*, February 12, 1988.

95. Lynn, "Saving the Merritt," 9.

96. *Stamford Advocate*, "Traffic Beast Threatens Parkway's Beauty," September 3, 1990.

97. *New York Times*, "Merritt Faces a Fight for Its Future," August 5, 1990.

98. Connecticut Trust For Historic Preservation, "A Preliminary Response to the State of Connecticut's Proposed Expansion of the Merritt Parkway," 1990.

99. *Hartford Courant*, "Leave the Merritt Unimpaired," April 10, 1991.

100. "Merritt Parkway," *Connecticut Preservation News* (November/December 1990).

101. "Merritt Parkway Advisory Committee Named," *Connecticut Preservation News* (May/June 1992).

102. Emil Frankel, Interview by Jill Smyth, August 7, 2014.

103. *Merritt Parkway Guidelines for General Maintenance and Transportation Improvements*, Merritt Parkway Working Group, June 1994, 1.

104. Historic Roads, http:www.historicroads.org/sub4_5.htm.

105. *Hartford Courant*, "DOT Must Design and Include," April 7, 2006.

106. *New Haven Register*, "Biden Touts Stimulus in Roadside Visit: Vice President Stumps Dodd, Himes at Parkway Project Site," October 6, 2009.

107. *Stamford Advocate*, "Merritt Parkway Deemed Endangered by National Trust," May 19, 2010.

108. John Russell, *Reading Russell: Essays 1941–1988 on Ideas, Literature, Art, Theater, Music, Places, and Persons* (New York: H.N. Abrams, 1989).

Index

About the Authors

Laurie started her professional career at IBM, continuing at GE in consulting and sales management. She is a founding member of the Redding Preservation Society and the Fairfield County Preservation Network. Active on the boards of the Redding Land Trust and the Merritt Parkway Conservancy, she is the previous executive director of the conservancy. Along with her family, she restored a 1767 saltbox and an 1830s farmstead where the barns and outbuildings are listed on the state historic register.

Jill Smyth has been involved with the Merritt Parkway Conservancy since 2002 and currently serves as executive director. She is currently a member of the Merritt Parkway Advisory Committee, Stamford Historic Preservation Advisory Commission, Stamford Garden Club and Connecticut Tree Wardens Association, and she is a master gardener. She lives in Stamford and has two sons.

Visit us at
www.historypress.net
..
This title is also available as an e-book